IMAGES
of America

MCKEESPORT

On the cover: The view from the hospital steps shows National Tube Works in operation. Residents were very familiar with the smoke and dirt emitted from the blast furnaces of the mill. St. Pius Church is in the right corner; to the left are Christy's Drug Store and Fitzpatrick's Restaurant (a hangout for hospital workers). (Courtesy of the McKeesport Heritage Center Collection.)

McKeesport Heritage Center Volunteers

Copyright © 2007 by McKeesport Heritage Center Volunteers
ISBN 978-0-7385-4985-9

Published by Arcadia Publishing
Charleston SC, Chicago IL, Portsmouth NH, San Francisco CA

Printed in the United States of America

Library of Congress Catalog Card Number: 2006938523

For all general information contact Arcadia Publishing at:
Telephone 843-853-2070
Fax 843-853-0044
E-mail sales@arcadiapublishing.com
For customer service and orders:
Toll-Free 1-888-313-2665

Visit us on the Internet at www.arcadiapublishing.com

Dedicated to the immigrants who left their homelands to build a city where future generations could live in freedom. Their spirit lives on.

Contents

Acknowledgments 6

Introduction 7

1. Around the Town 9
2. Business and Industry 25
3. Community Services 49
4. Schools and Churches 57
5. Clubs, Organizations, and Culture 75
6. Parks 87
7. Memorable Events 99
8. Familiar Faces 103
9. Just for Fun 113

Acknowledgments

Since the McKeesport Heritage Center was founded in 1980, the members and residents of the area have donated photographs, memorabilia, and records that have provided us with the rich history of the city. It was through their generosity and love of the past that we were able to put this book together and share it with the public. The following answered our call for photographs: Marilyn Baldwin, Betty Blumen, Jan Catalogna, City of McKeesport, *Daily News* collection, Ray Dougherty, Faith Lutheran Church, P. J. Gallagher, Suzanne Heatherington, Anthony Jordan, Barbara Vance Libengood, Minerva Bakery, Edith Robis Collection, Irvin P. Saylor Collection, Doris Stipkovits, and Judy Shermer Wolf.

We also wish to express our appreciation to the following people who helped immeasurably with this book: Tom Barlow, Audrey Casperson, Clifford Flegal, Robert Hauser, Joe Martin, Frank Rinelli, Darryl Segina, Francis Show, Gail Waite, DeWayne and Evette Wivagg, Harold Byer, Sam LaRosa Jr., and Ron Brooks.

We would like to thank the following members of the Heritage Center Board of Directors for their continued support of the volunteers: Marilyn Baldwin, J. Terrance Farrell, Robert Hauser, William C. Hunter, Duane Junker, Bernadine H. Kovacs, Irv Latterman, Robert Messner, Daniel Piesik, Ruth Richards, JoAnne Rodgers, Francis Show, Sue Ann Striffler, and DeWayne Wivagg.

We especially want to acknowledge Cynthia Neish, one of the founders of the McKeesport Heritage Center. For over 20 years she served as the director of the center. Her dedication to the preservation of the rich history of McKeesport provided us with the research materials and photographs found throughout the book. With her passing in September 2006, she left a center to be enjoyed by all.

Thanks to the McKeesport Heritage Center volunteers who, for eight months, labored over the words and photographs necessary to document the history of the McKeesport area and create this book. We recognize the following: Elsie Boucek, Justin Brooks, Joyce Couch, Arlene Gallagher, Janet Grebeck, Rita Holub, Joyce MacGregor, LaVerne McConnell, Ellen Vasey Show, and Nancy Weller.

Introduction

The Monongahela and Youghiogheny Rivers have always played a central role in the history of McKeesport, starting with the meeting on the banks of the Monongahela River of George Washington and Queen Aliquippa in 1753. Soon after, Gen. Edward Braddock and his troops, with aide-de-camp George Washington, journeyed through what is now White Oak and McKeesport to engage the French and drive them from western Pennsylvania.

John Frazier, a trapper, had a cabin in the area and is considered the first settler. Next came the McKee family—the patriarch, David; his wife, Margaret; their sons, Robert, James, Thomas, David, and John; and their daughters, Margaret and Mary. In 1755, they arrived at the point where the two rivers met and cleared the land for cabins and farming. McKee started a skiff ferry over both rivers, and soon other families followed to McKee's Ferry, as it was then known. In 1769, the McKees bought several tracts of land from the colonial land office. John, McKee's son, laid out 200 lots, which he offered for sale in 1795 when the name was changed to McKee's Port. After the Native Americans were subdued in Pontiac's War, the area continued to grow. The town that McKee founded had access to the rivers for transportation of raw materials, coal deposits in the immediate area, lumber for building, and an influx of settlers. It was inevitable that industry would flourish there.

In 1851, W. DeWees Wood purchased land on the northeast corner of Walnut and Water Streets and erected an iron works. Later this became a rolling mill, which was incorporated as the W. DeWees Wood Company, and produced sheet iron. Thus the groundwork was laid for the industry that would make McKeesport an iron and steel center. The Flagler Company from Boston, Massachusetts, moved there in 1870 and renamed itself the National Tube Works. The National Tube Works, W. DeWees Wood Company, and the American Sheet Association merged to become the U.S. Seamless Tube Company in 1896. A consolidation of 13 major tube and pipe producers created the National Tube Company in 1899, and it became a subsidiary of U.S. Steel in 1901. McKeesport became known as "Tube City" and attracted other companies in the 19th and 20th centuries, such as Carnegie (later U.S. Steel), Kelsey Hayes, Firth Sterling, Continental Can, and Fisher Body. The products coming out of McKeesport helped the United States win two world wars and contributed to a heightened standard of living for its citizens.

These industries needed workers, and they arrived in droves. Coming from Hungary, Czechoslovakia, Poland, Italy, Yugoslavia, Ireland, Sweden, Greece, and Germany, they joined the English and Scots-Irish already there. They came from the tiny villages and shtetls (small towns) of Europe—some with just the clothes they could carry—to join others from their families or from their villages to start the process of becoming an American. After the Civil War, many

blacks migrated north for the jobs and opportunities offered, all bringing their families, their religions, their customs, and ethnic foods. Perhaps most importantly, they brought a work ethic that contributed to the success of business and industry in western Pennsylvania.

They built houses, churches, church schools, and social halls, including the Irish Ancient Order of Hibernians, the German Turners, the Swedish Singing Society, and the Greek American Progressive Association. And, in so doing, each group left a strong mark on this city. Education was important and so were sports. Home, family, church, school, and workplace—these were the keystones of a good life. When the Bessemer Converters lit up the night sky, McKeesporters prospered. It was not the most beautiful spot in the state, but during the glory days of the steel industry in the Mon Valley, it seemed beautiful to those who worked and thrived here.

The city continued to grow. In the 1950s, the census was up to 55,000. All went well for a while, but two conditions led to the decline of the city. In the mid-1960s, shopping malls became very popular, taking business away from the downtown shopping district and forcing the closing of local stores. The collapse of big steel in the 1980s led to a lack of jobs and the further demise of many small businesses. Fifth Avenue no longer bustled with activity, and the furnaces no longer lit up the sky. In 2000, the city census showed 24,000 inhabitants. Most of the vacant mill structures were torn down and, for the first time in decades, the rivers were accessible to the general public.

Today several technology firms have located to the former mill sites and McKeesport, under a new mayor, has embarked on a renewal program that has demolished abandoned housing, built new recreational facilities, repaired streets, and worked to improve the face of the city and restore the pride of those who were born and raised here.

This book is to show something of the city and its inhabitants as they were and life as it was.

One
Around the Town

In the early days, getting around town was most likely done on foot or, perhaps, on horseback. Horses were rented by the day from a livery, and eventually, horse and buggy was the way to navigate. The ferryboat would take folks across the Youghiogheny and Monongahela Rivers. Later trolleys carried folks around town and to other cities like Pittsburgh. And, of course, the train ran through the center of town. As the city grew and industry increased, the scenes around town changed. Locals remember crowded downtown streets on a Saturday, the old neighborhoods, familiar businesses, and community celebrations.

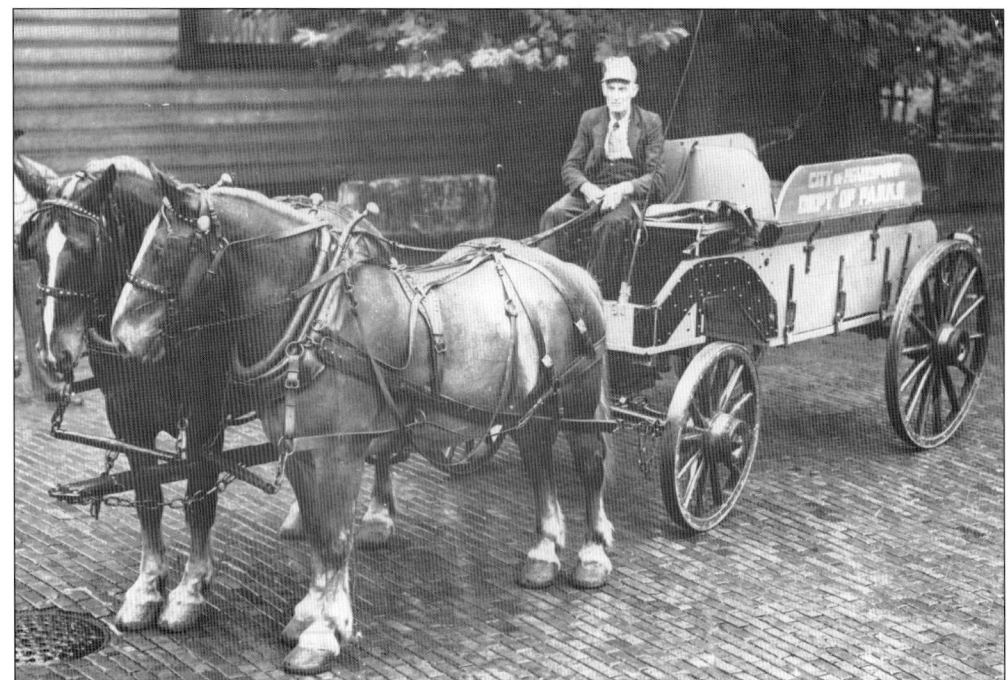

Transportation in 1938 was not all trains, streetcars, and automobiles. The City of McKeesport Department of Parks still traveled by horse and buckboard. In this photograph, driver Frank Smith preferred a railroad hat to a cowboy hat.

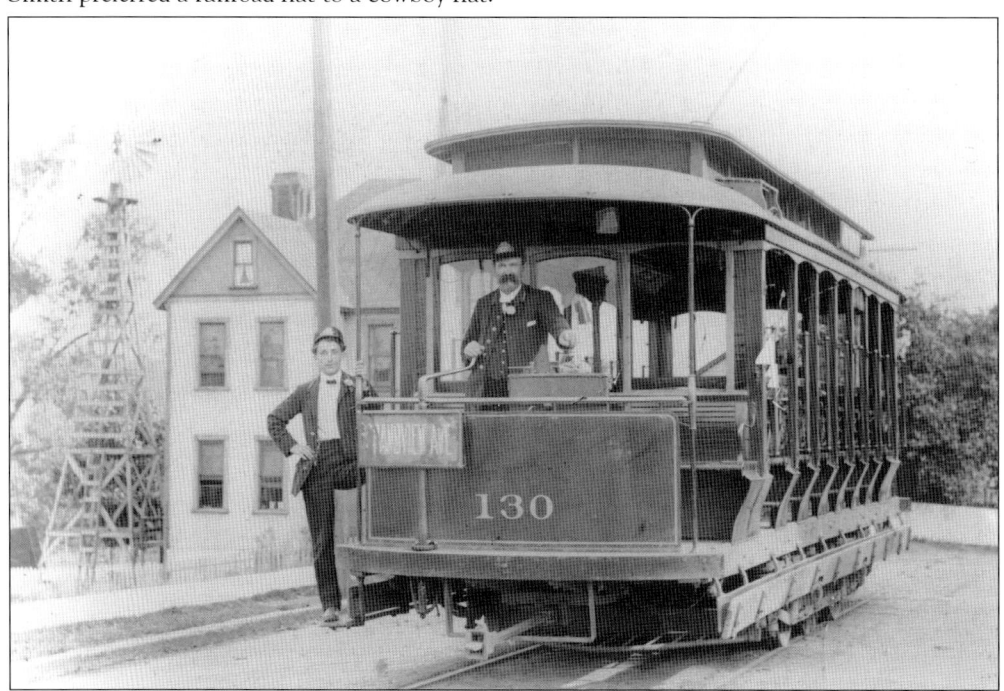

Grandview Avenue was serviced by trolley car No. 130 around 1900. Note the gas well at the left behind a residence in the 2700 block of Grandview Avenue. That is conductor Edward B. Ayres to the left of the trolley.

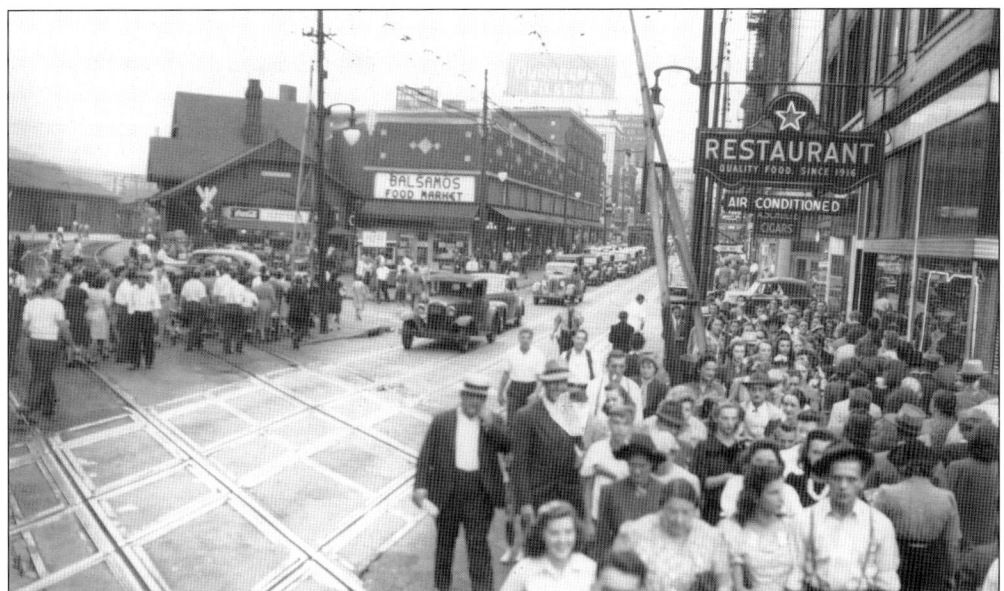

Beating the "trains through the middle of town" during the 1930s, residents scurry through downtown McKeesport at the Fifth Avenue and Locust Street intersection. Pictured in the background is Balsamo's Food Market, the city's first supermarket. After its closing in 1974, its sturdy brown shopping bags, known as McKeesport luggage, became collector's items. The Star Restaurant at the Baltimore and Ohio Railroad crossing boasted the best pies in town. Note the trolley tracks that also contributed to hazardous driving.

After nearly 60 years of discussion about the removal of the train tracks that bisected the city, the tracks are still very much in evidence in this picture. This is a major intersection in the shopping district, and long trains could cause delays of up to 20 minutes several times a day. It was a unique feature that a lot of merchants and shoppers could have done without.

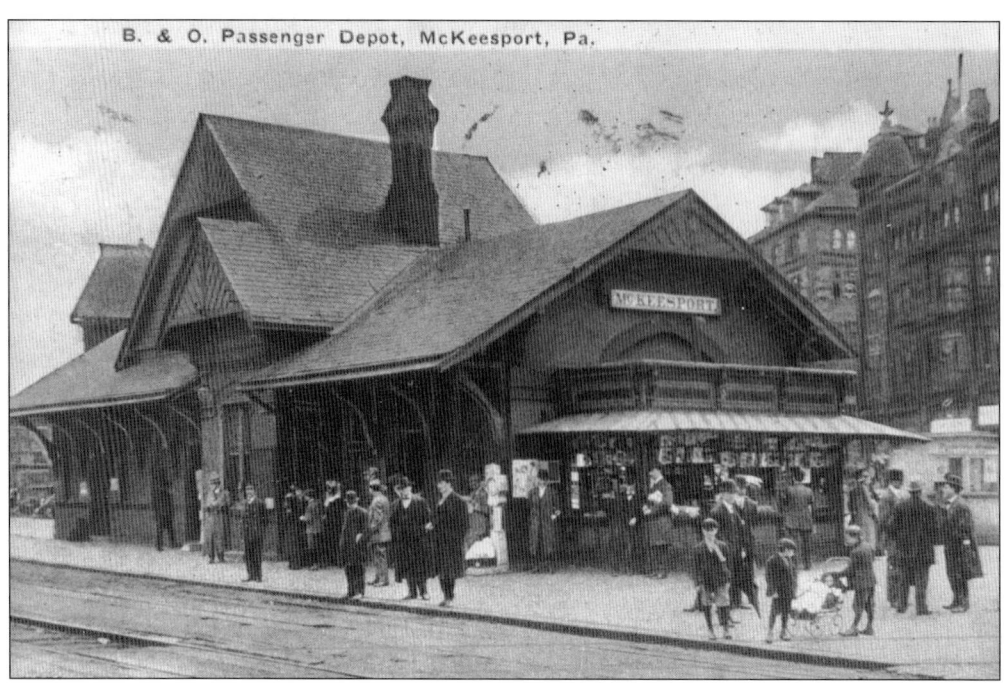

The Capitol Limited, which originated in Chicago, would stop at this depot for passengers going to Washington and Baltimore. McKeesporters enjoyed the train service traveling to the big city of Pittsburgh.

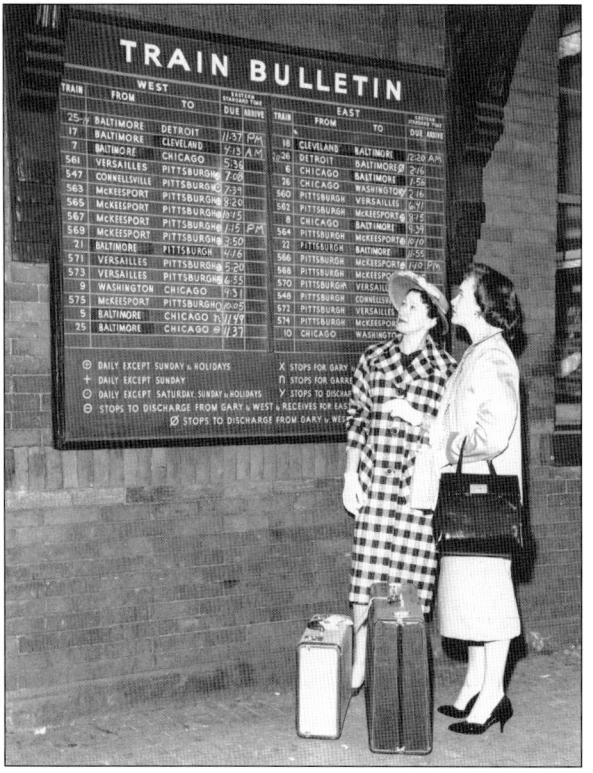

In the late 1950s, Christmas travelers at the Baltimore and Ohio Railroad station are shown checking the bulletin board to see that the trains are running on schedule. Note the number of trains running east and west.

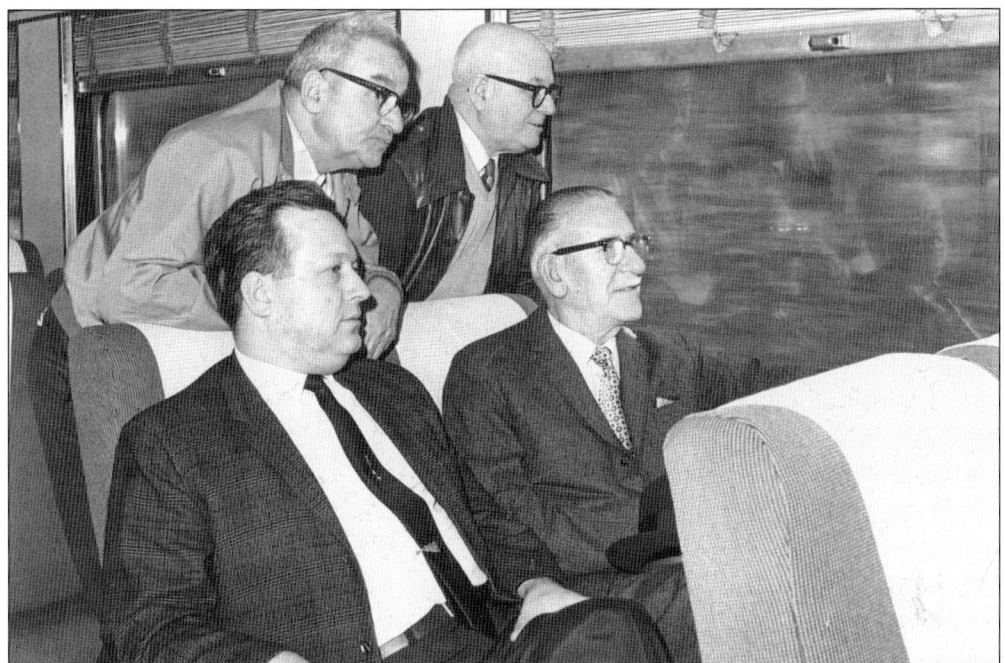
The Columbian was the commuter train used by McKeesporters. The last time it left McKeesport was in 1972. Pictured here from left to right are train aficionados (seated) Dr. Donald Beck and Glenn Hirshberger, and (standing) Angelo Pittner and Peter Greco.

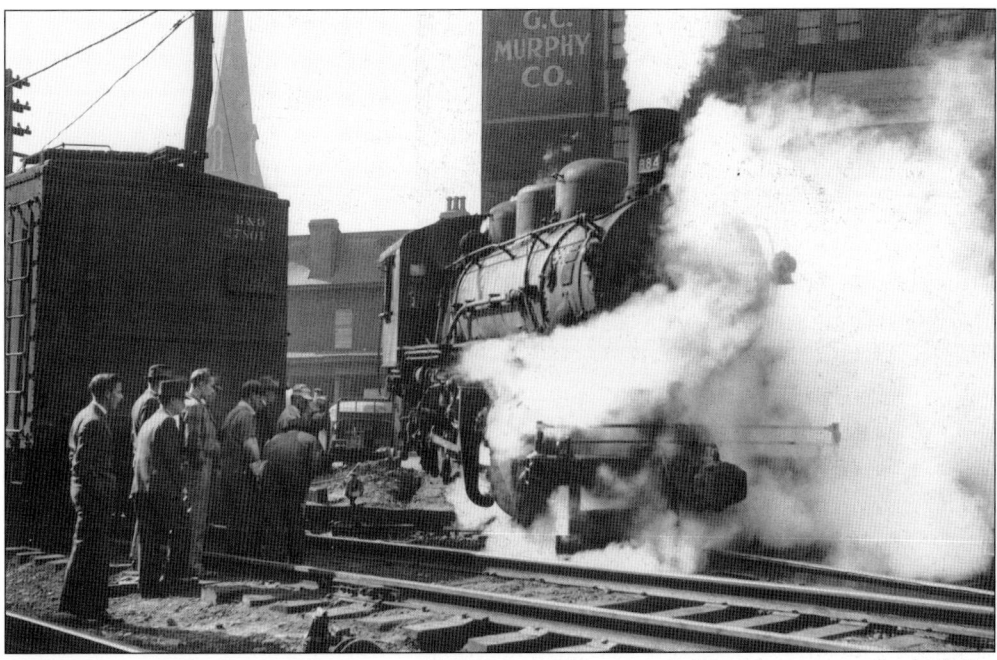
The renovation phase of McKeesport included the relocation of the rails running through the heart of the business section. The classic steam engine in the picture served the G. C. Murphy Company warehouse located off Walnut Street in Christy Park. Workers are shown standing in line at the crossing.

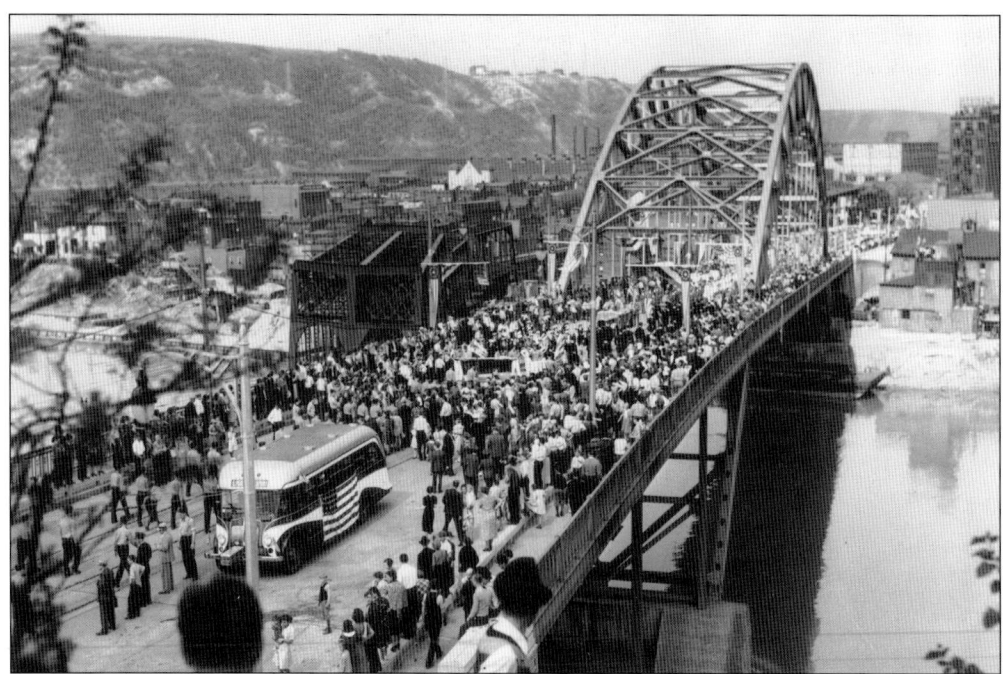

Throngs of people came out for the dedication of the Jerome Street Bridge in May 1938. The span across the Youghiogheny River links McKeesport's downtown to the 10th Ward.

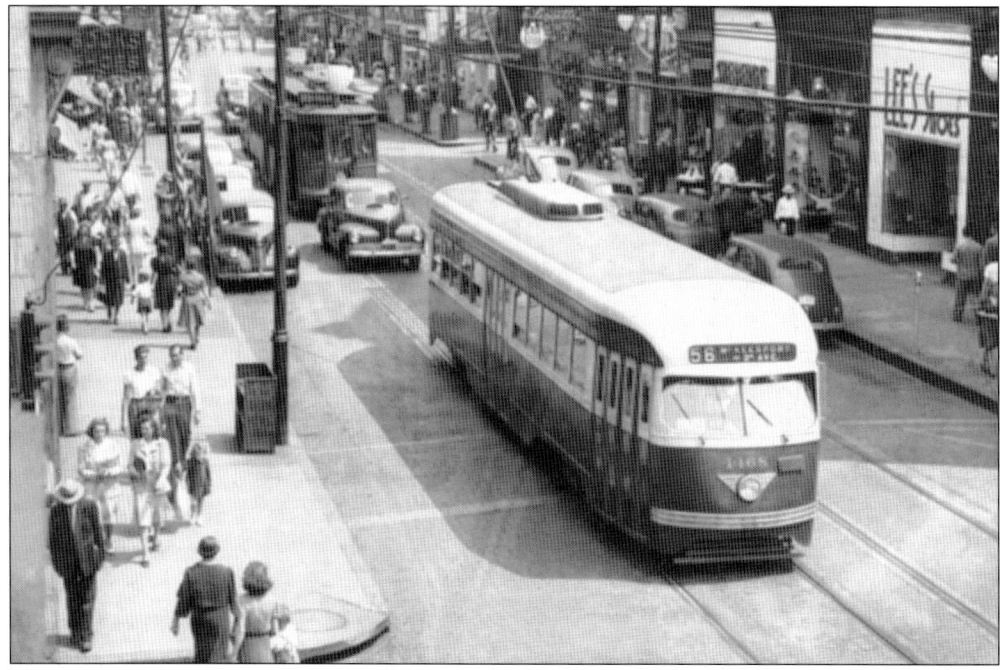

The No. 99 streetcar in the back of the photograph had a cow catcher on the front, and the interior had wicker seats. The No. 56 was one of two streetcars that went from McKeesport to downtown Pittsburgh. In some parts of town, the streets were so narrow that if cars did not park against the curb the streetcars could not get through. The conductor would ring warning bells, and if the owner did not respond, the car would be towed.

This early 1950s shot of Fifth Avenue shows many familiar businesses of the era. The obvious absence of people in the picture may indicate early morning hours before the stores had opened. The local No. 99 streetcar passes Green's Five and Ten in this photograph.

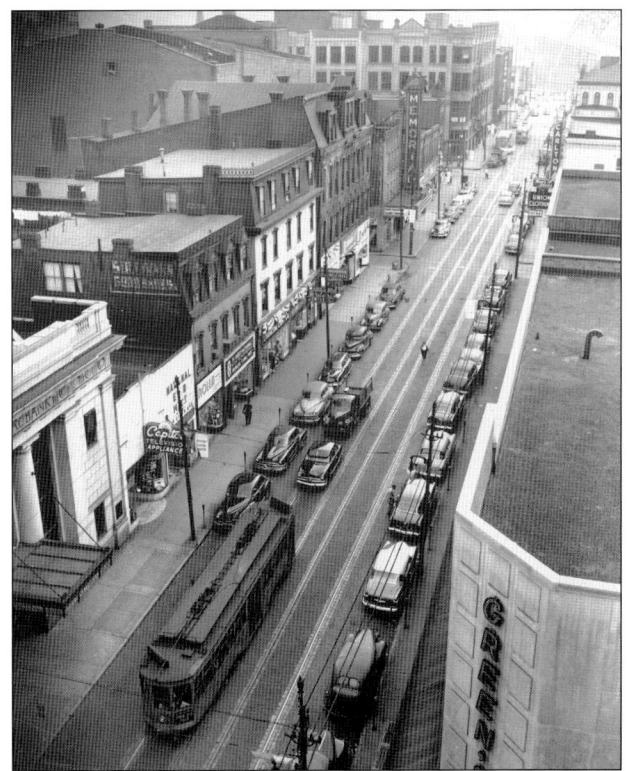

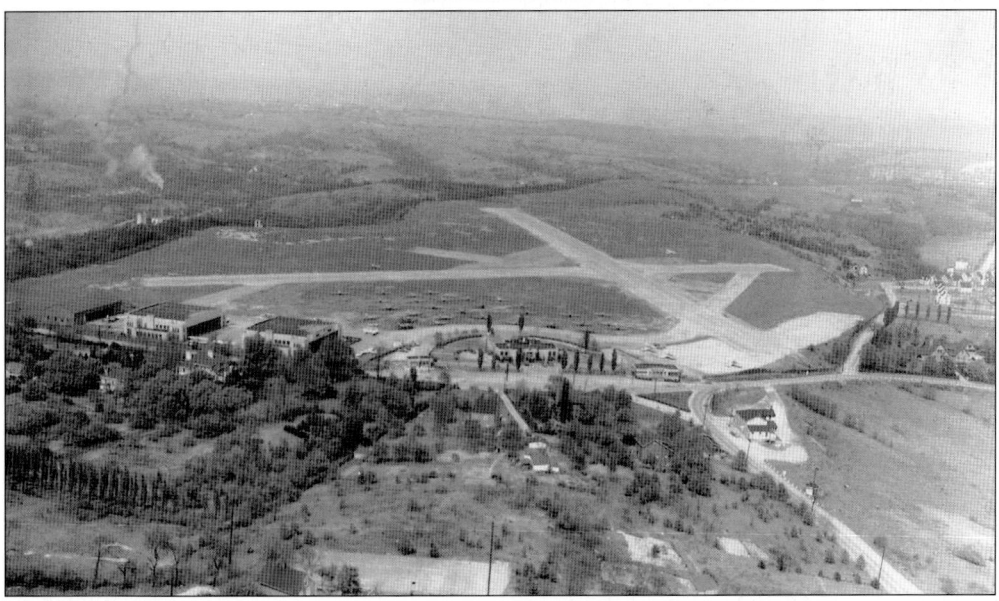

In 1925, pilot Cyrus Bettis was declared "the fastest man alive" after flying 249 miles per hour. The next year, he was killed in a plane crash, and the Pittsburgh-McKeesport Airdrome, at the juncture of McKeesport-Pittsburgh Boulevard and Bettis Road, was renamed Bettis Airfield in his memory. Charles Lindbergh landed at Bettis Airfield in his *Spirit of St. Louis* after his famous 1927 transatlantic flight. The career of Helen Richey started there. Westinghouse bought Bettis Airfield in 1949 and closed it.

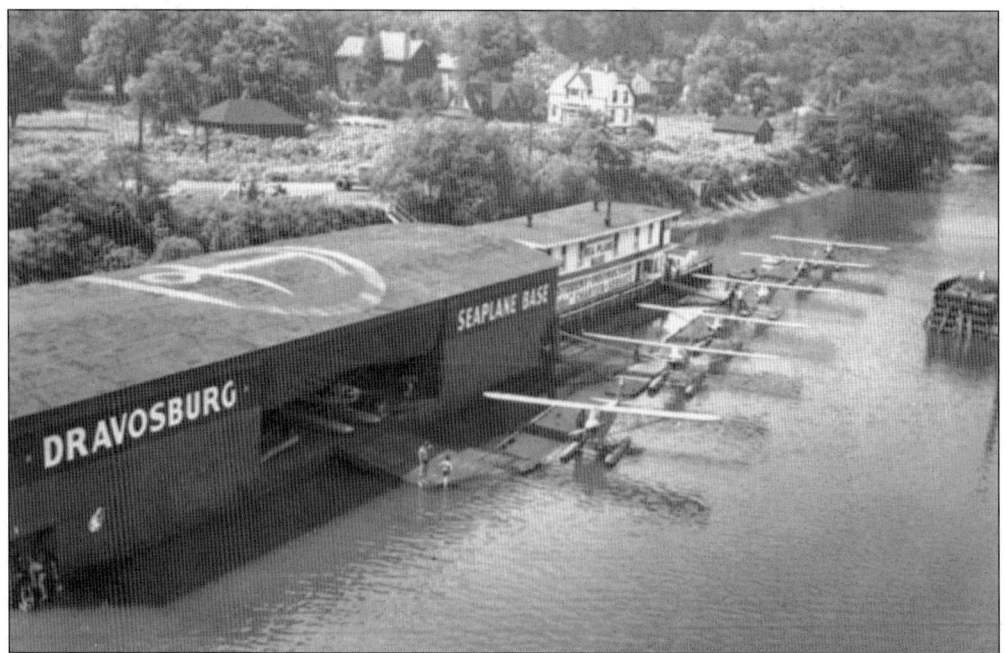

Dr. Frawley, a local pharmaceutical representative, set up a river barge as a seaplane hangar to give lessons for $3 and rides for the public in the early 1940s. Located under the old Dravosburg Bridge off Washington Boulevard, this enterprise ended at the beginning of World War II because the pilots were needed for the war effort.

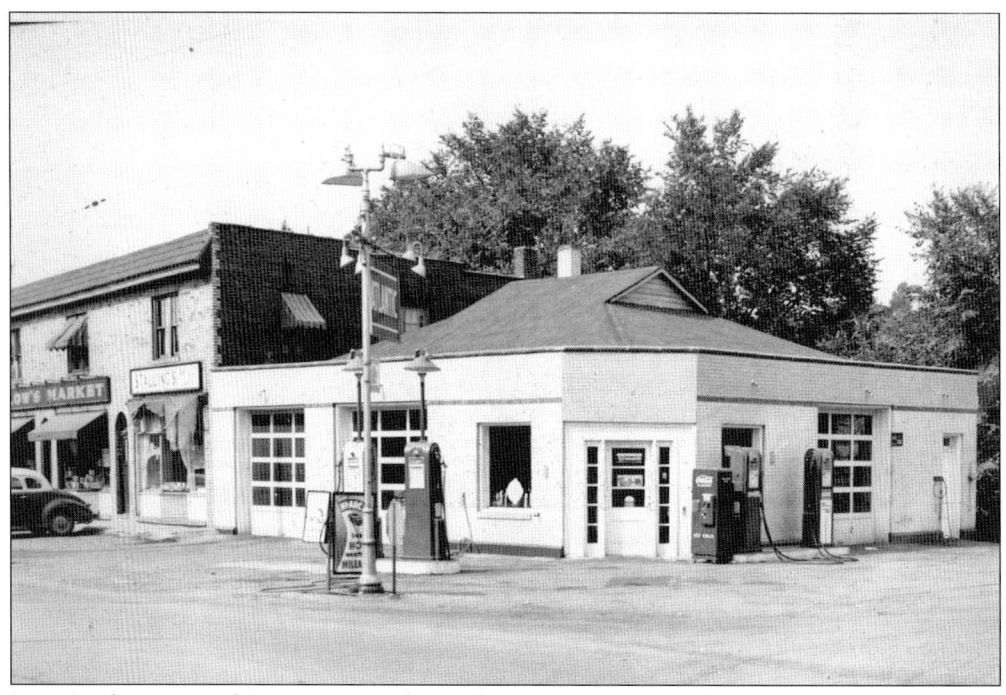

In 1953, the corner of State Street and Lincoln Way was a major pocket of commerce. William Mehaffey's garage was right next door to Stalling's Dairy and Edlow's Market.

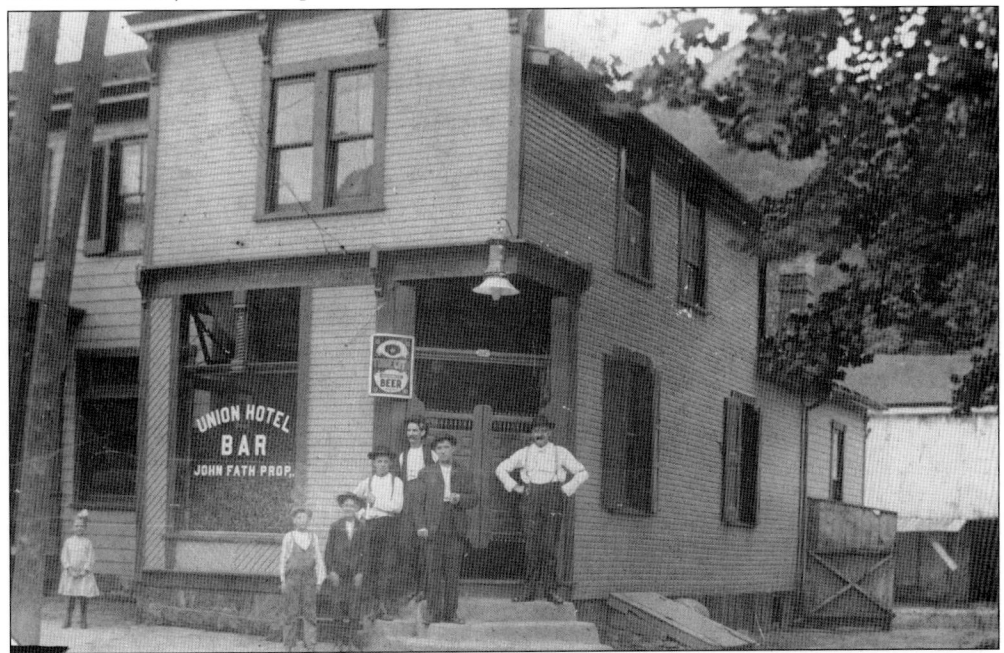

Hotel Dandar, at the corner of Locust and Jerome Streets, was one of the larger "traveling men's" hotels in the city of McKeesport.

The old Union Hotel and Bar was located on Fifth Avenue between Hartman and Fawcett Streets. One of its prominent patrons was D. L. Clark, who often came in with a basket of Zigzag candy bars to give to the other patrons. Clark's candy business later moved from McKeesport to Pittsburgh. The young girl in the picture is Vera Steele. The hotel thrived until the Prohibition era.

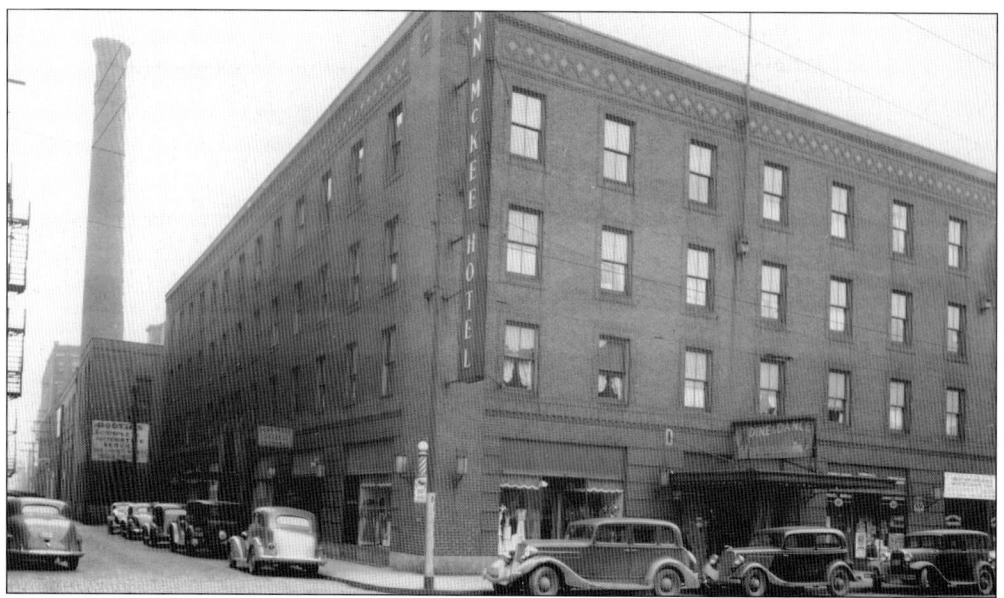

The Penn-McKee Hotel opened on September 1, 1926. The old saying was, "If it happens in McKeesport, it happens at the Penn McKee." It had 100 guest rooms (60 with connecting bathrooms), the Crystal Ballroom, a cocktail lounge, the Monte Carlo room (affectionately knows as the "passion pit"), a coffee shop, and a lunch room. Junior congressmen John F. Kennedy and Richard M. Nixon debated there, and Pres. Harry S. Truman had lunch at the hotel. The Penn-McKee Hotel closed in March 1980.

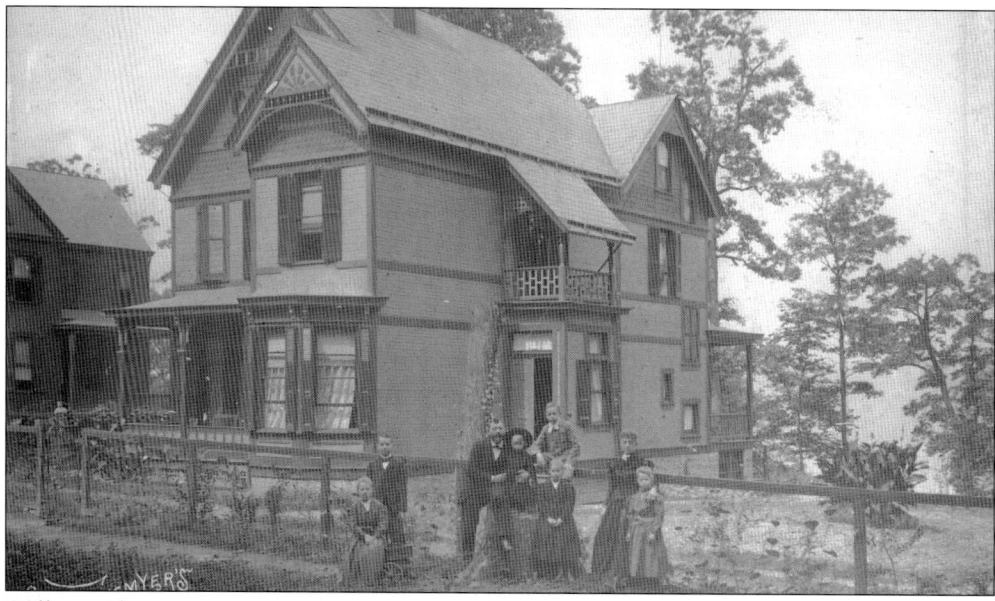

William Christian Cronemeyer of Highland Grove was born in Germany. He immigrated to the United States, and in 1873, he was asked to assist in organizing the United States Iron and Tin Plate Company at Demmler Station. He was dubbed "father of the tin plate industry" by Alabama congressman Judge Turner. Cronemeyer was one of the organizers of the McKeesport Chamber of Commerce and served as its first president. His house shown above still stands on Bowman Avenue in Highland Grove.

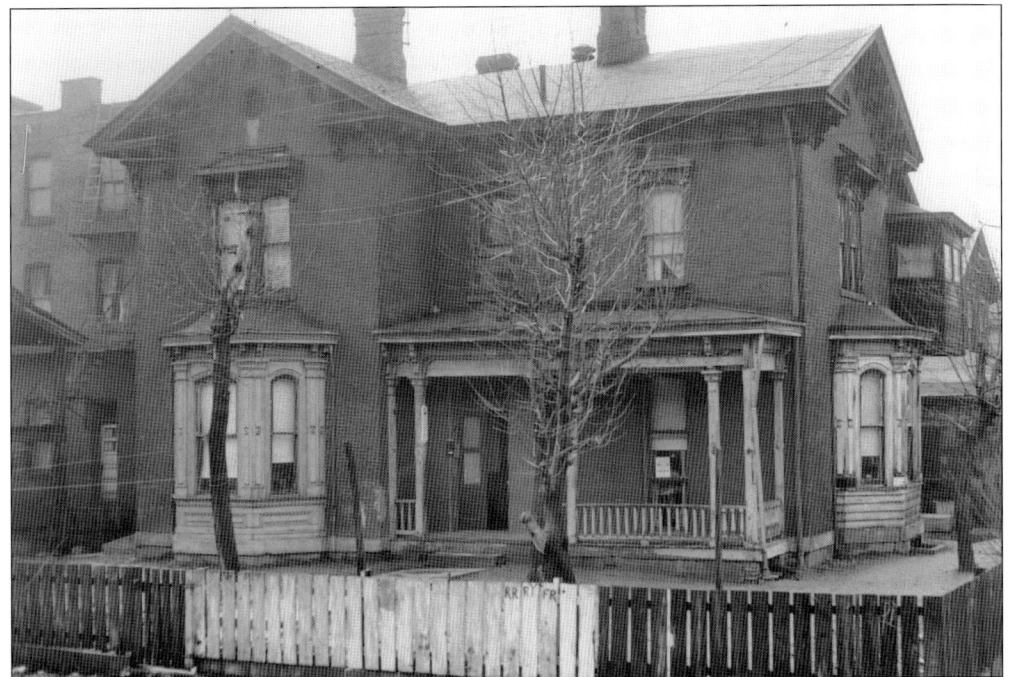

Ferry boat captain Quincy A. McClure's home overlooking the Youghiogheny River was located at Second Avenue and Water Street in the 1st Ward. In later years, David Rosenberg, city councilman from 1909 to 1927, occupied the home. Built prior to 1876, the structure was demolished in 1960.

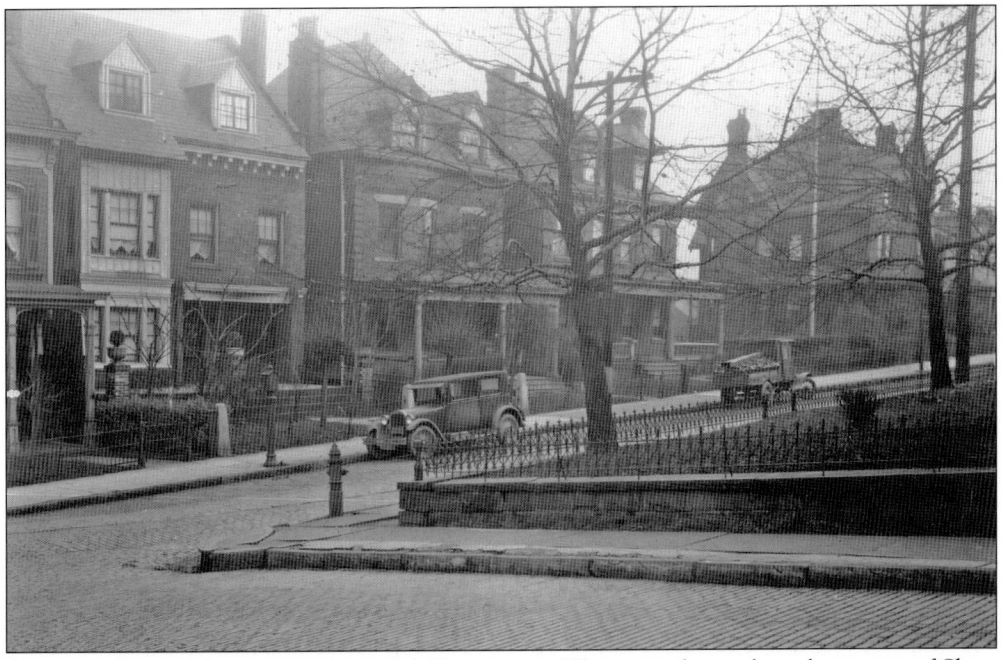

These are homes of some prominent McKeesporters. They were located on the corner of Shaw and Huey Streets in 1928. From left to right are the homes of F. W. Walker, Dr. Noah Sunstein, Isaac Sunstein, Adolph Schmidt, Mayor G. Lysle, and R. C. Painter.

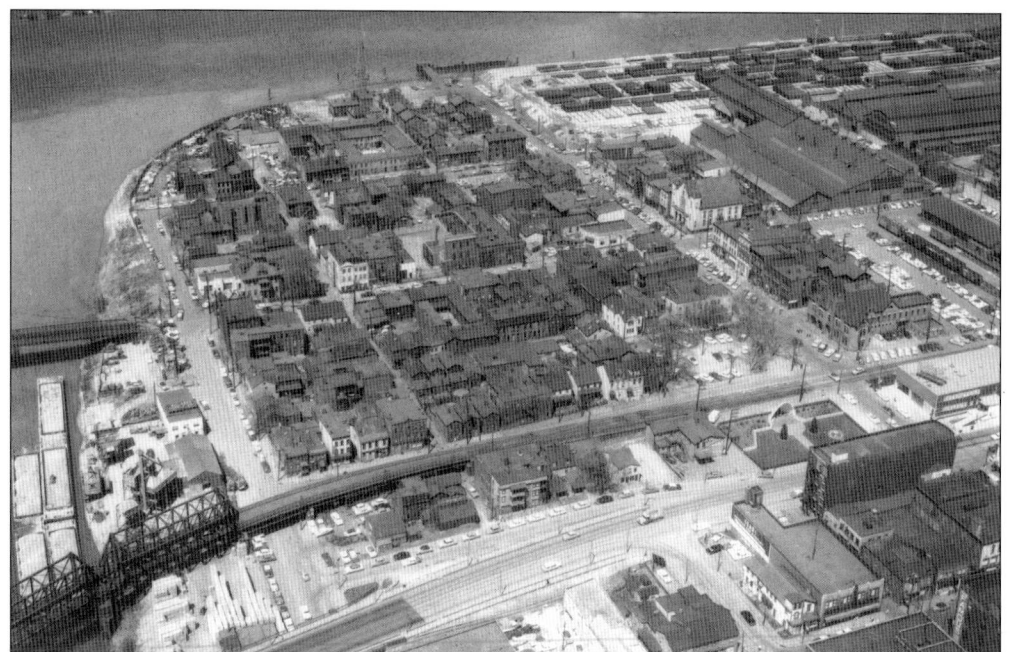

When founder David McKee arrived, he settled at the confluence of the Youghiogheny and Monongahela Rivers. Immigrants to the area settled in what became the 1st Ward, shown in this aerial view. In 1959, 240 families were relocated and the homes were demolished to make room for the U.S. Steel's expansion.

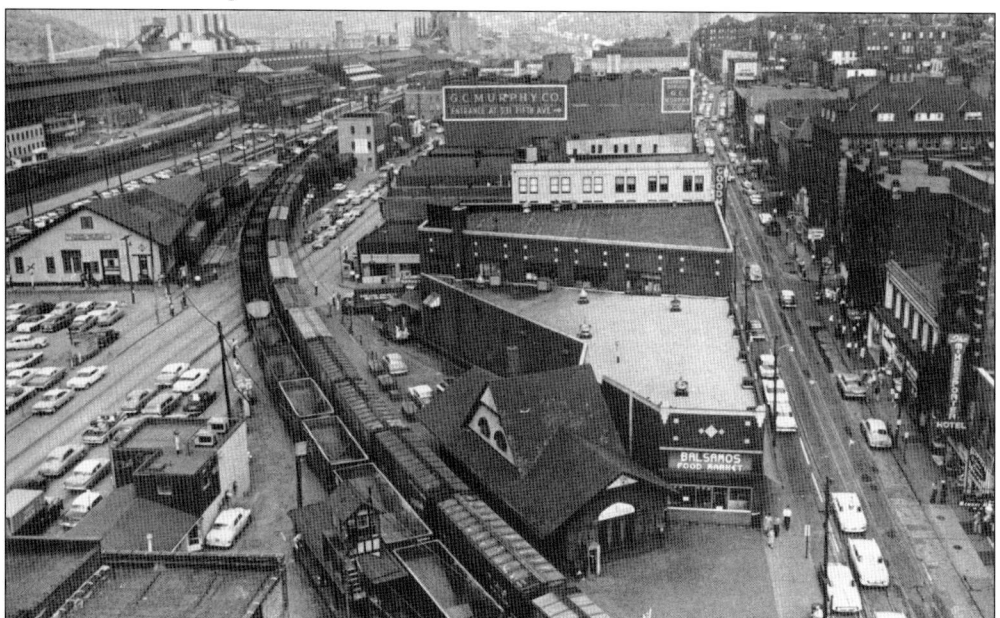

At one time, the city had trains running through the center of town, bringing pedestrian and car traffic to a halt on both sides of the tracks. Long trains could cause major disruptions. For years, city leaders talked about the need to redirect the trains, and in 1970, that change was finally made. In the foreground is the train station that sat between Balsamo's Market and the Club Car Diner.

Is this New York City? No, wait, it is Fifth Avenue in McKeesport in the 1950s. The city was in its heyday and was the hub of activity for the entire region.

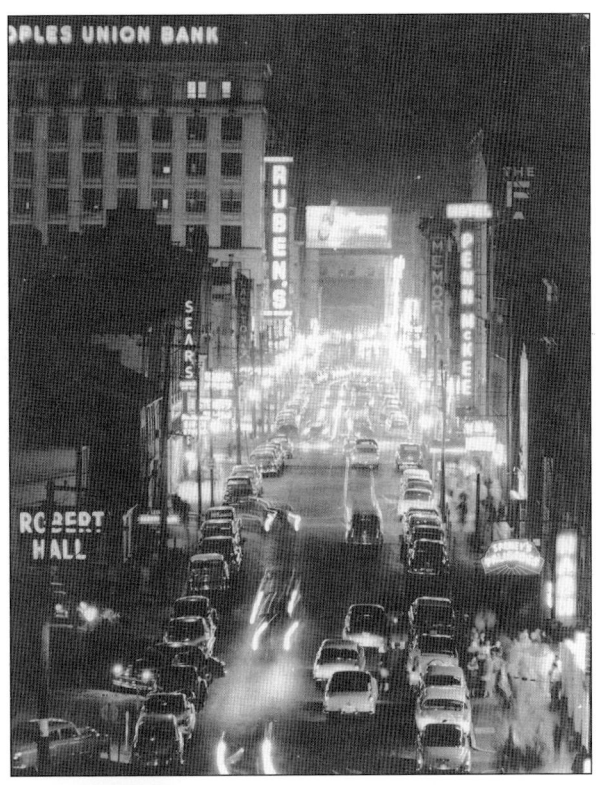

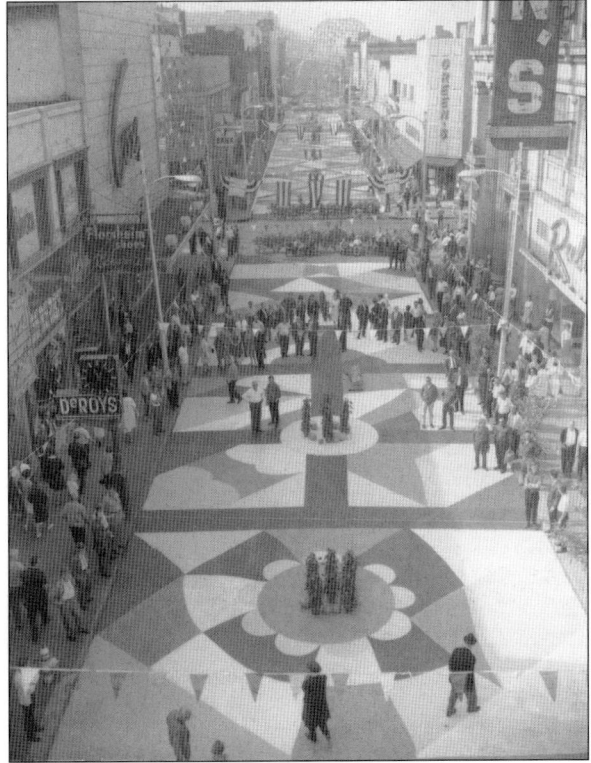

In the early 1960s, malls became a part of the area's shopping scene. To compete with this, the city, under Mayor Andrew J. Jakomas, decided to turn Fifth Avenue into a shopping mall. No cars could be driven on Fifth Avenue, and shoppers could walk freely on the street. However, a few years later, the street was returned to the automobiles as the experiment failed dismally.

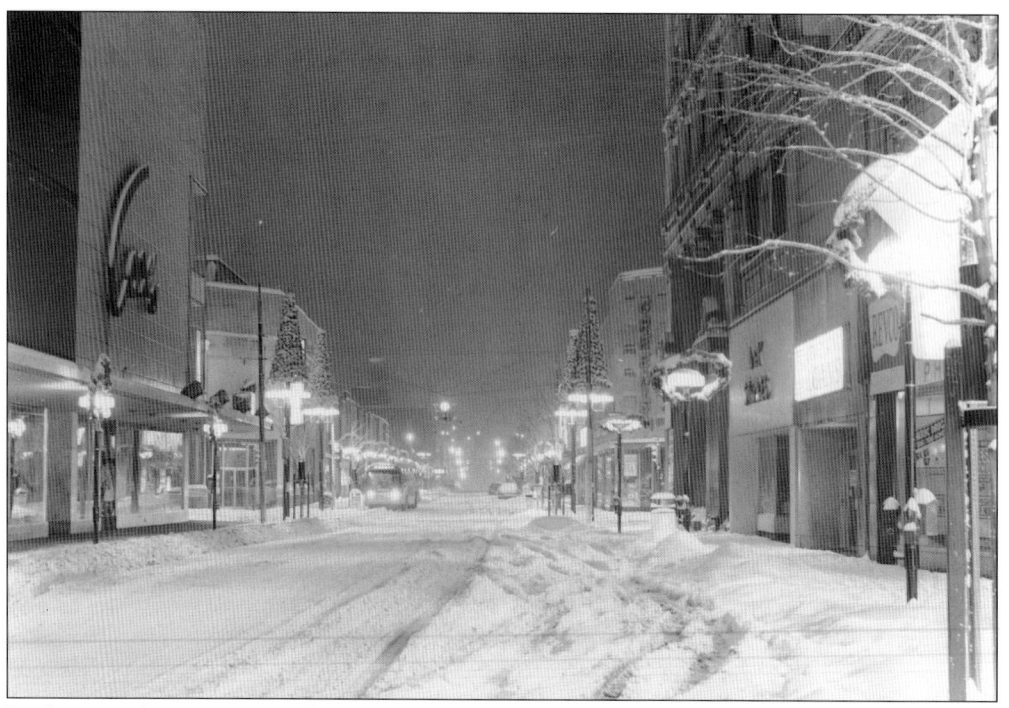

Looking at the snow-covered main thoroughfare, one would not know it was a steelmaking center. It looks beautiful in its holiday finery with Cox's and Green's Five and Ten center stage.

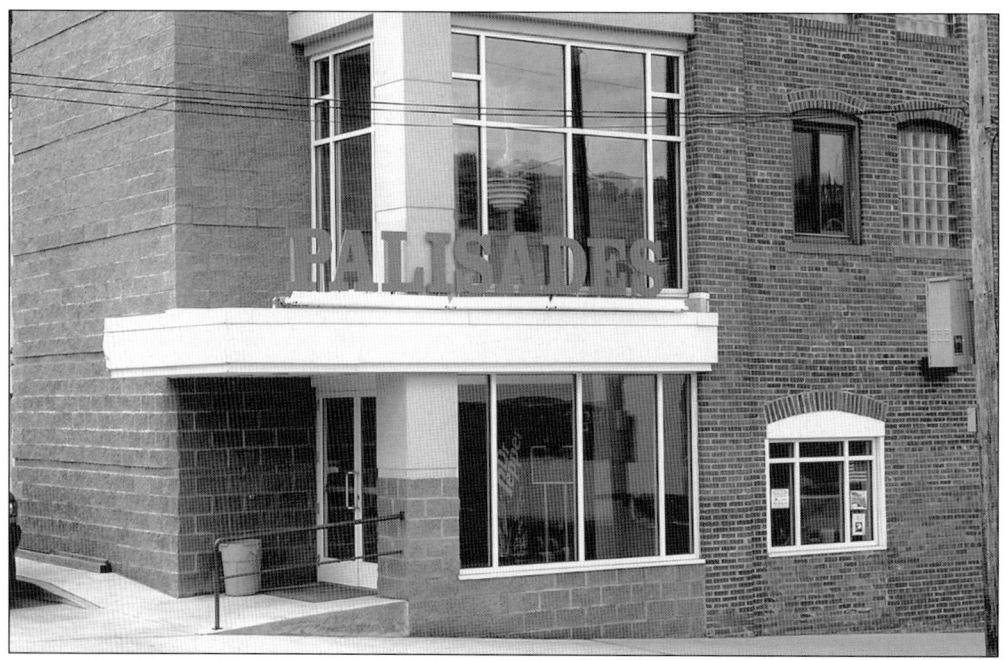

Remembered as a venue for such events as boxing, automobile shows, and roller skating, the Palisades building later housed various businesses. Recently renovated, the banquet hall on the second floor is the site of many ballroom dances, parties, reunions, and other social gatherings. It is adjacent to the McKee's Point Marina.

Long before new houses were built in the Haler Heights section (or "Pill Hill"), the land was owned by the Haler family. Members shown here include Charlie Haler (second row, third from left).

Around 1964, the residents of homes along Marshall Drive in Haler Heights installed flag holders in their front yards. At left is DeWayne "Dewey" Wivagg, and third from the left is Irvin Saylor.

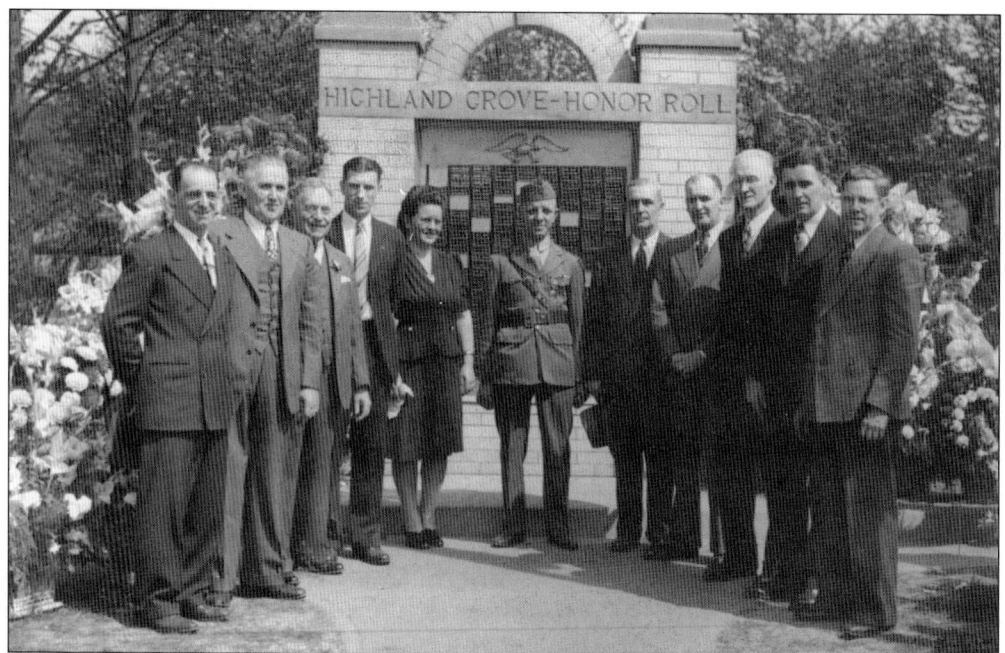

Highland Grove residents rally around the new World War II monument dedicated in 1945. The proud residents are, from left to right, John Shaffer, Michael Hanko, Carl Bechtol, Anthony Flicker, Elizabeth Steck, John Weiss, Charles Steck, Walter Brocard, Clarence Whitehead, Francis McAraw, and Al Morris.

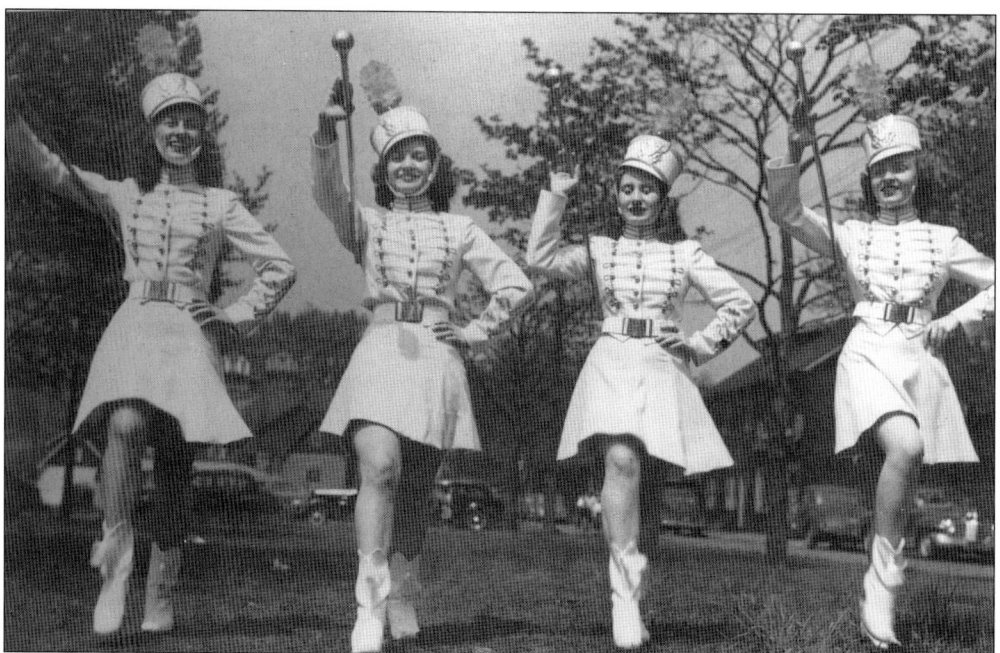

Following World War II, churches and neighborhoods took great pride in honoring residents who fought so gallantly in the war. McKeesport High School majorettes strut their stuff at the dedication of the Highland Grove Honor Roll on May 20, 1945. Shown from left to right are Jeanne Boe, Dolores Dispensa, Dolores McDivett, and Catherine Chalfant.

Two

BUSINESS AND INDUSTRY

David McKee can be called the first businessman in the area. When he arrived in 1755, he ran a ferry across both the Monongahela and the Youghiogheny Rivers. The earliest businesses in the village reflected the needs of the immigrants who settled there: rope making, blacksmithing, liveries, and taverns. In 1855, W. DeWees Wood introduced the ironworks and eventually, the steel mills dominated the area. There was easy access to raw materials and transportation on the rivers, and it was not long before immigrants from all over Europe flocked to the city to provide labor. When U. S. Steel opened National Tube Works and Christy Park Works, the city flourished.

The growing population required support businesses, such as hotels, groceries, drugstores, breweries, barbershops, and restaurants. Many of these were family-run and some exist to this day. The *Daily News* has been the paper of record since 1884. There were also several corporate headquarters in McKeesport. The G. C. Murphy Company (Murphy's 5 and 10¢ Store) had its corporate offices on Fifth Avenue, while Potter McCune, the largest food distributor between New York and Chicago, chose Walnut Street to locate its headquarters. The Clark Candy Company started in the city and later relocated to Pittsburgh. Times have changed, and industry has much less of a presence in the Mon Valley than it did in the glory days. McKeesport has attracted several smaller high-tech companies, including Maglev and Echostar, which have set up shop in some of the former National Tube buildings. Blueroof Technologies has built several houses filled with state-of-the-art facilities for senior citizens in the 2nd Ward. These companies have begun to regenerate industry in the Mon Valley.

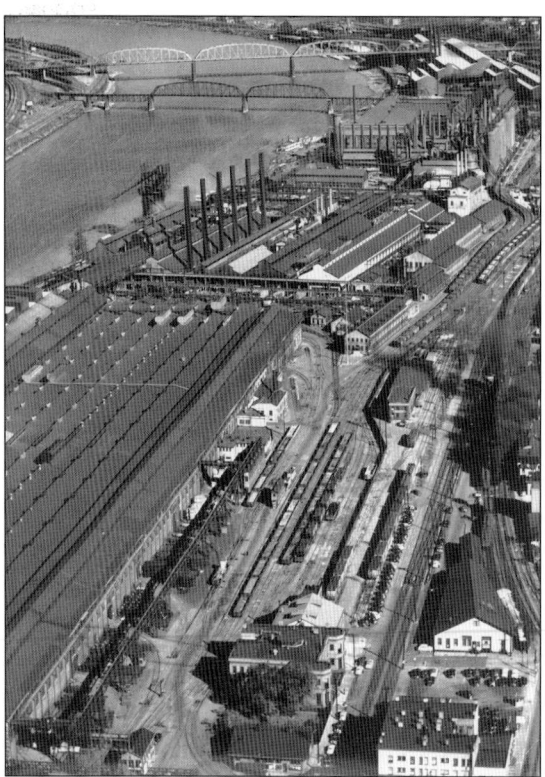

The U.S. Steel National Tube Works in McKeesport was 1.6 miles long and occupied 133 acres along the Monongahela River. This aerial view shows the size and complexity of this major industrial plant located in the heart of the city.

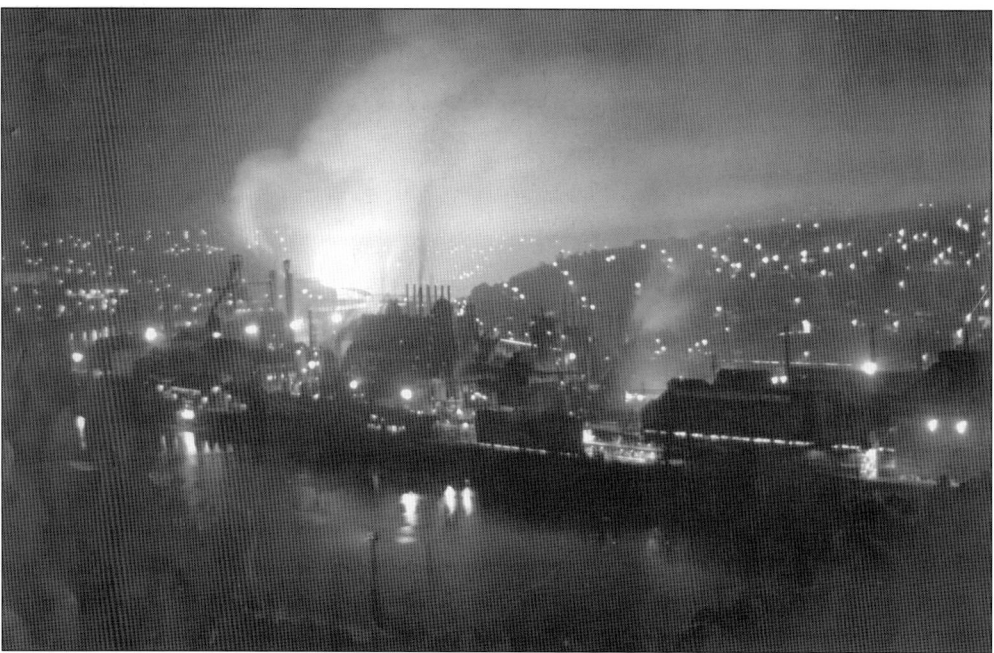

Everyone who grew up in McKeesport would undoubtedly remember the orange glow and reflections of light on the river caused by the "Bessemer Blow." This photograph was taken during the last blow at National Tube Works in 1965. After that time, steel came from Duquesne Works. Duquesne Works is in the foreground.

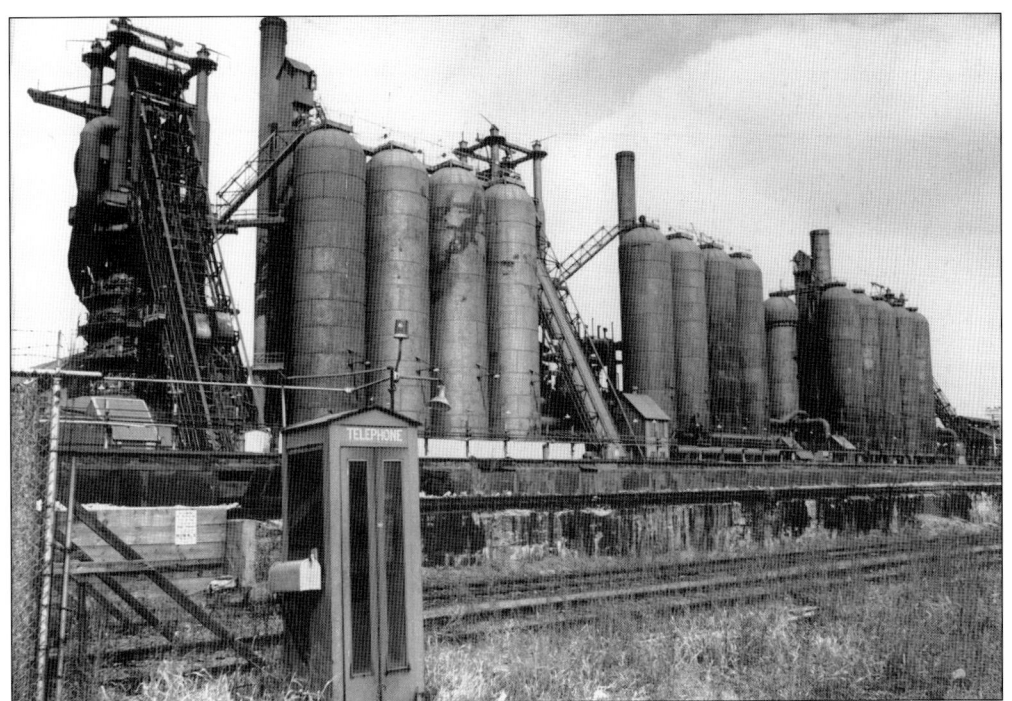

The blast furnaces of U.S. Steel National Tube Works were a familiar sight to many growing up in McKeesport. This photograph shows a telephone booth and mailbox outside the mill property.

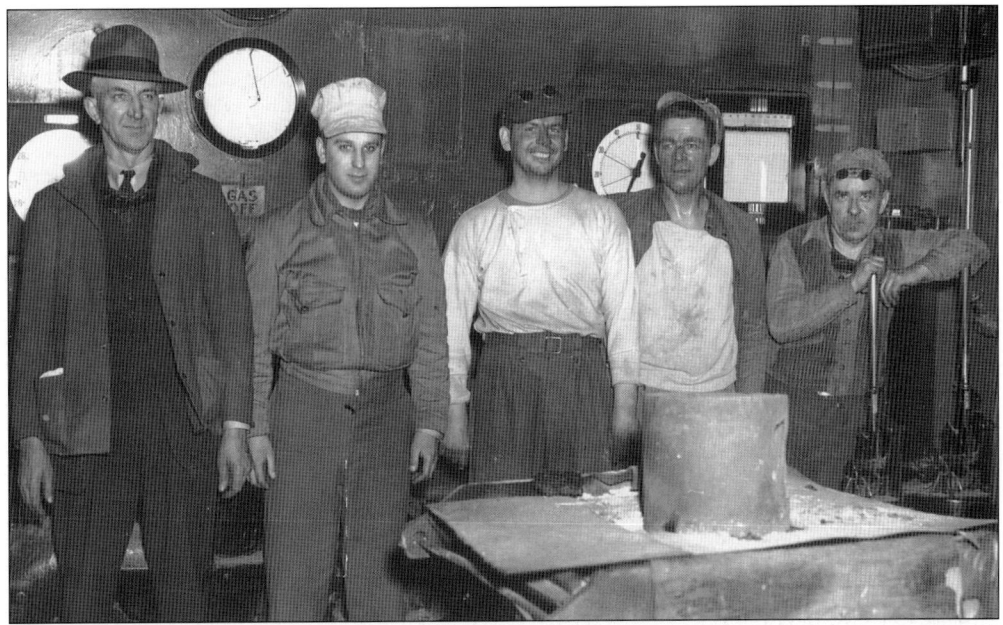

Workers of the open-hearth furnaces at National Tube Works are shown on the job. Notice the complete lack of protective garments, except for protective glasses, worn by the workers. Furnace temperatures in that part of the mill would reach 2,900 degrees Fahrenheit. Over the years, protective gear was added to protect the workers from the intense heat. Pictured from left to right are workers ? Crowley, ? Gonos, ? Conway, ? Hansen, and ? Stiers.

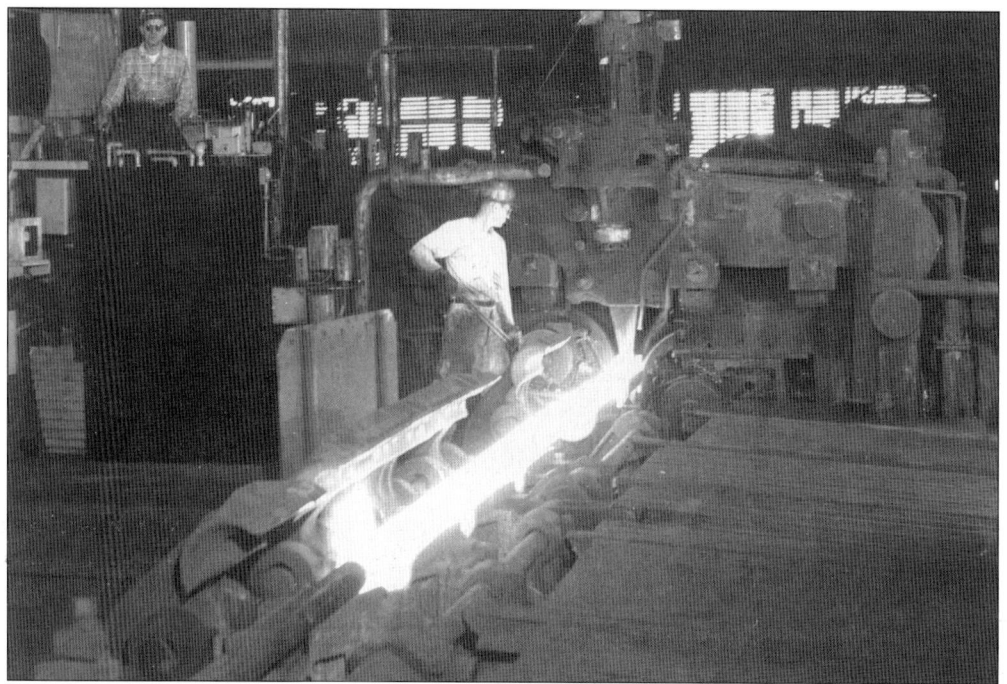

Working the No. 1 seamless hot mill at U.S. Steel National Tube Works was one of many dangerous and fiery jobs at the mill. The solid round billet is being pierced to create a seamless tube of steel. This was state-of-the-art tube making in the early 1960s.

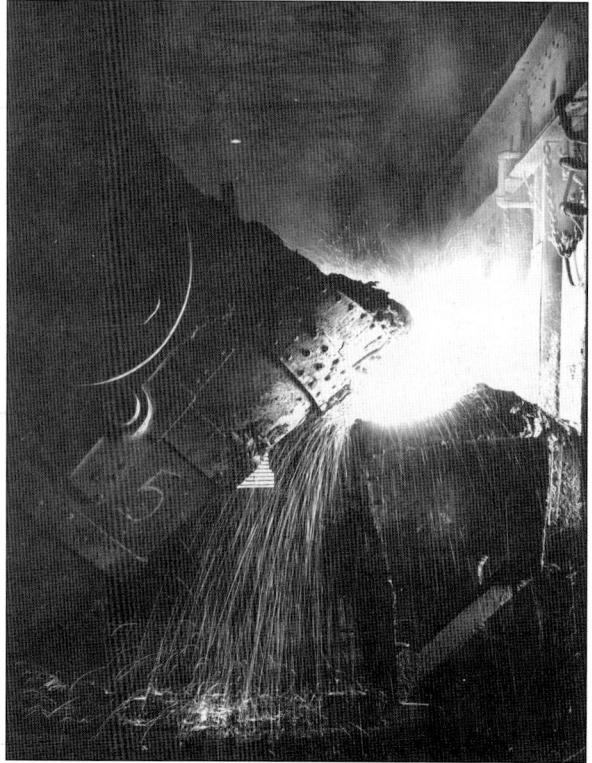

This dramatic photograph gives one the sense of the intense heat generated when pouring liquid iron from the blast furnace into a Bessemer Converter at the National Tube Works.

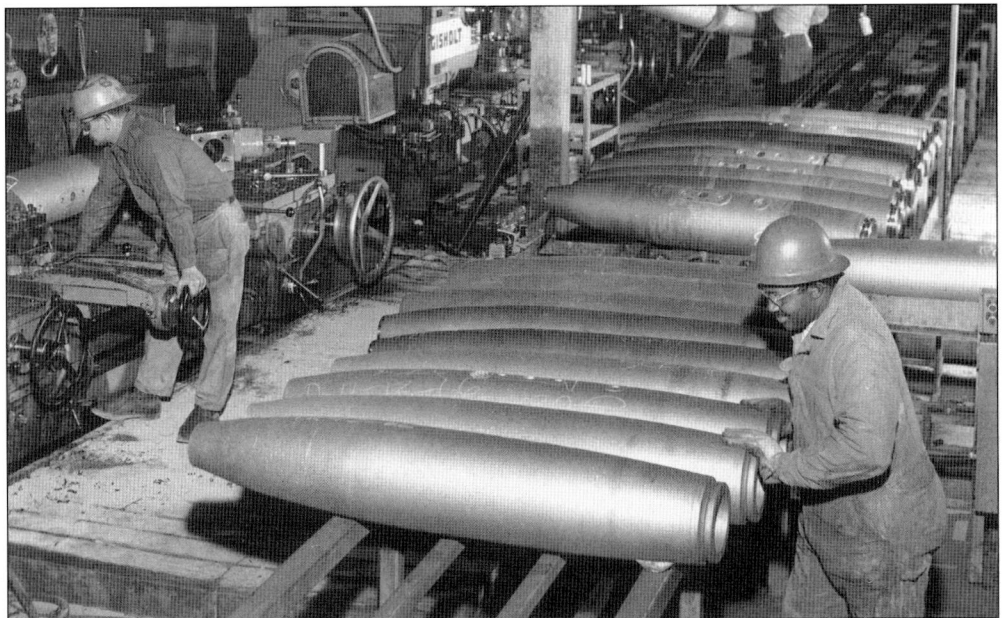

Workers at U.S. Steel's Christy Park Works on Walnut Street are shown finishing bomb casings during World War II. From 1940 through the end of the war in 1945, Christy Park produced over 22.6 million shells, 3.7 million bombs, 1.3 million rocket tubes, and one million cylinders and air flasks. At one time, Christy Park Works employed 7,500 people, but when the war ended and the government terminated its contracts, most workers lost their jobs.

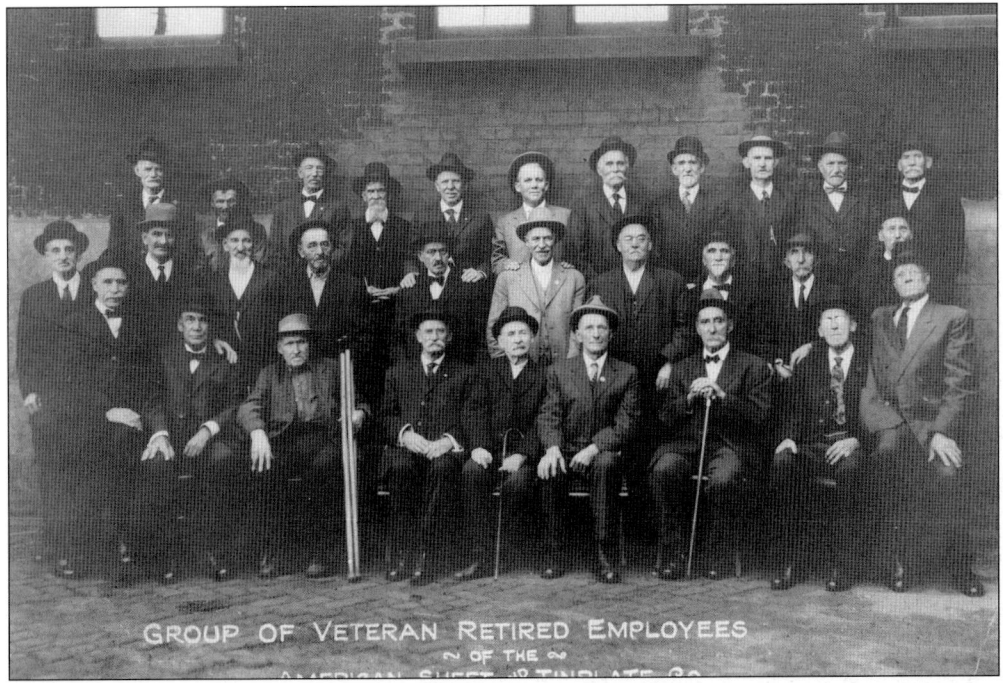

After humble beginnings in 1902, the American Sheet and Tinplate Company became the largest tinplate manufacturing facility in the world. Shown here in 1920 is a group of retired employees. John Surgeon is the seventh man from the left in the second row.

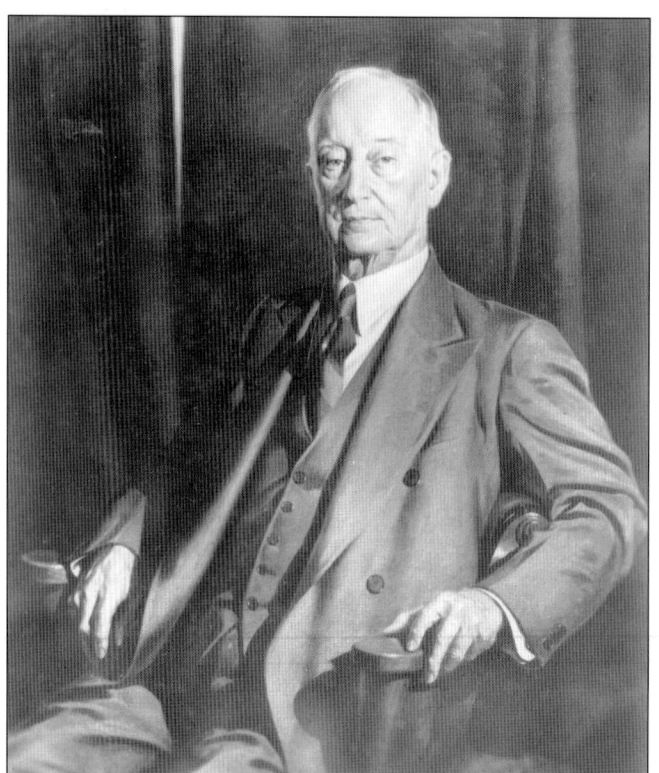

Firth Sterling Steel was incorporated in 1889 by Lewis John Firth of England. This plant was located under the McKeesport-Duquesne Bridge, where it produced high-grade specialty steels and powdered carbide that were primarily used for cutting tools. The facility closed in the mid-1960s.

In the early 1900s, prior to the passing of child labor laws, some of the laborers in the Firth Sterling Forging Department were extremely young to be working around such dangerous machinery.

The Hubbard Mine was located at the bottom of Eden Park Boulevard. Owned by Baton Coal Company, the mine opened in 1924 to remove the upper Freeport coal seam via 12 miles of tunnels extending into White Oak, North Huntingdon, and North Versailles. By 1956, it was owned by the Greensburg-Connellsville Coal and Coke Company, employing 240 men and producing around 2,300 tons per day. It closed in 1960.

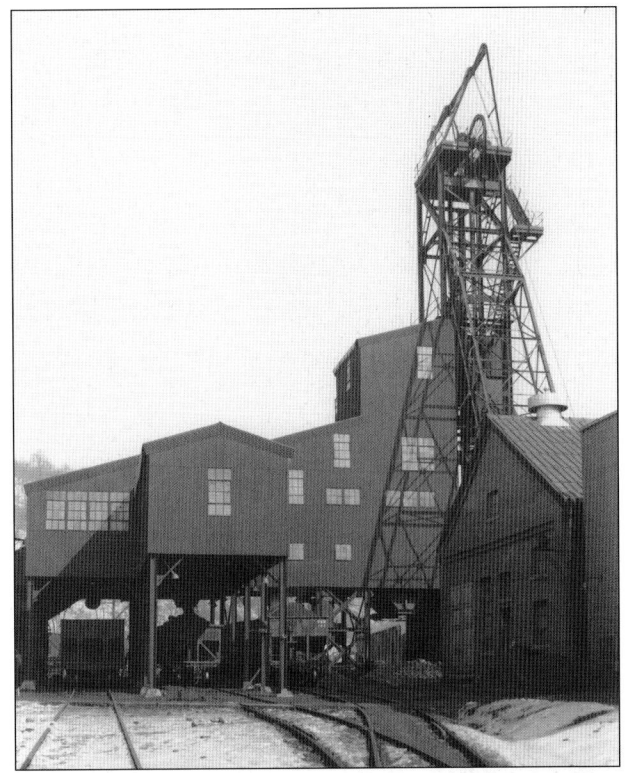

Hubbard Mine workers are seen being treated at McKeesport Hospital after a mining accident.

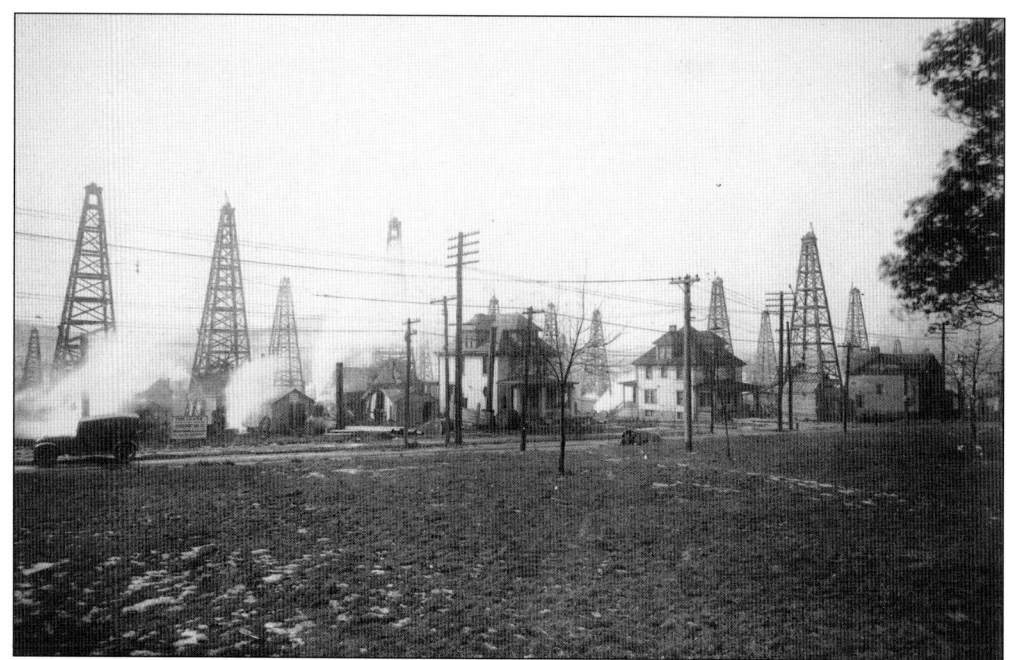

This photograph of Walnut Street was taken in 1920. It shows just a few of the natural gas wells drilled in Versailles. A lot of money was won and lost on these wells before they disappeared. By late 1921, even though there were 650 holes sunk in the area, little gas was being extracted. The brick house on the left is where the Bob Rodgers Insurance Agency is today.

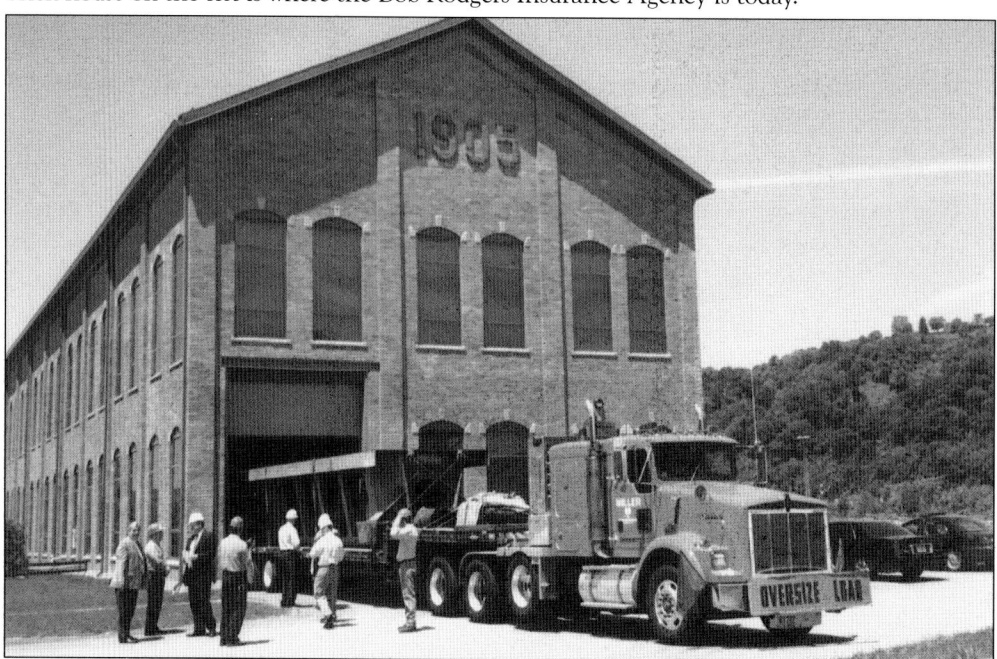

Maglev Incorporated now occupies some of the 1905 National Tube Works buildings and does research and development for the government and for high-speed transportation systems. Shown here is a section of an advance materials ship hull structure for the navy's new Stealth Ship Technologies Program ready to be shipped to Lehigh University for further fabrication.

For years, yellow brick facades with broken windows were a familiar sight along Lysle Boulevard. Buildings that formerly housed the finishing department of National Tube Works were retrofitted and now wear fresh paint and bright blue roofs. These are home to Echostar, a regional call center for troubleshooting in the satellite communications dish network.

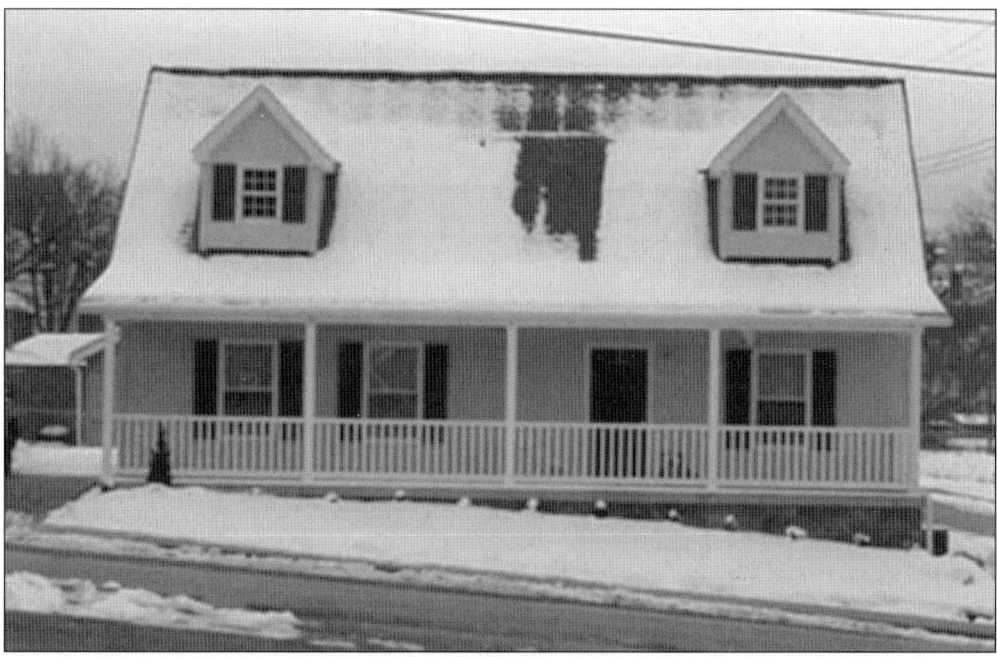

The city of McKeesport has embraced Blueroof Technologies, state-of-the-art living facilities for senior citizens that will allow them to live independently at home as long as possible. It is a goal of Blueroof Technologies to develop a comprehensive plan for the McKeesport area to become a leader in Senior Smart technology. This model cottage is located on Spring Street.

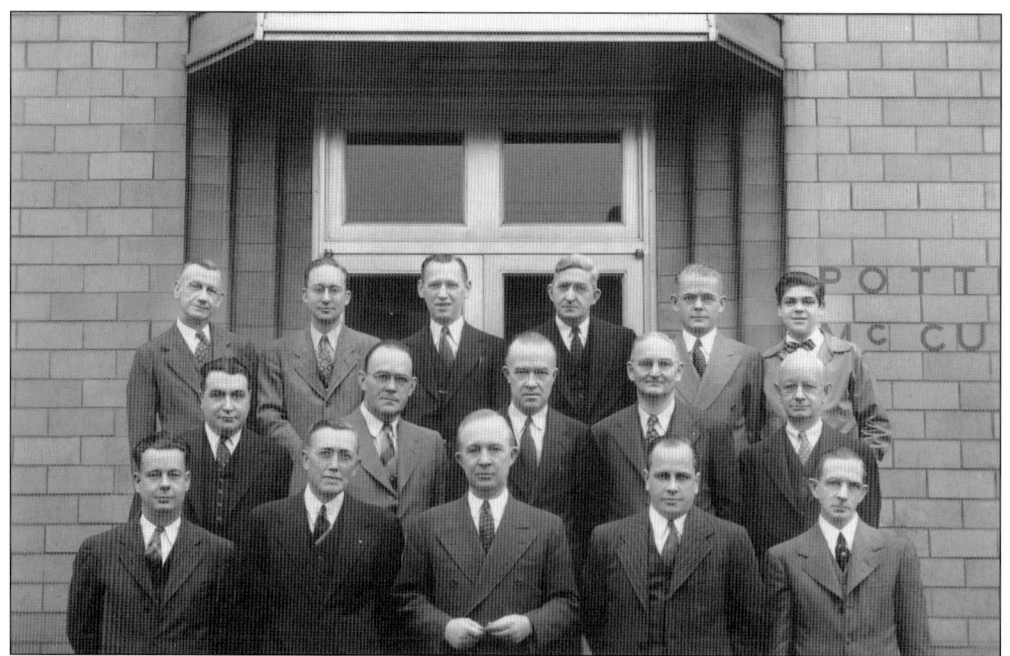

Potter McCune was a widely known local wholesale grocery company. Organized in 1908 by two men, H. C. McCune and John M. Potter, it was known as the largest food distributor between New York and Chicago. Shown here in 1944 is the management team; A. C. McCune, president, is third from the right in the first row; John McCune is second from the left in the top row.

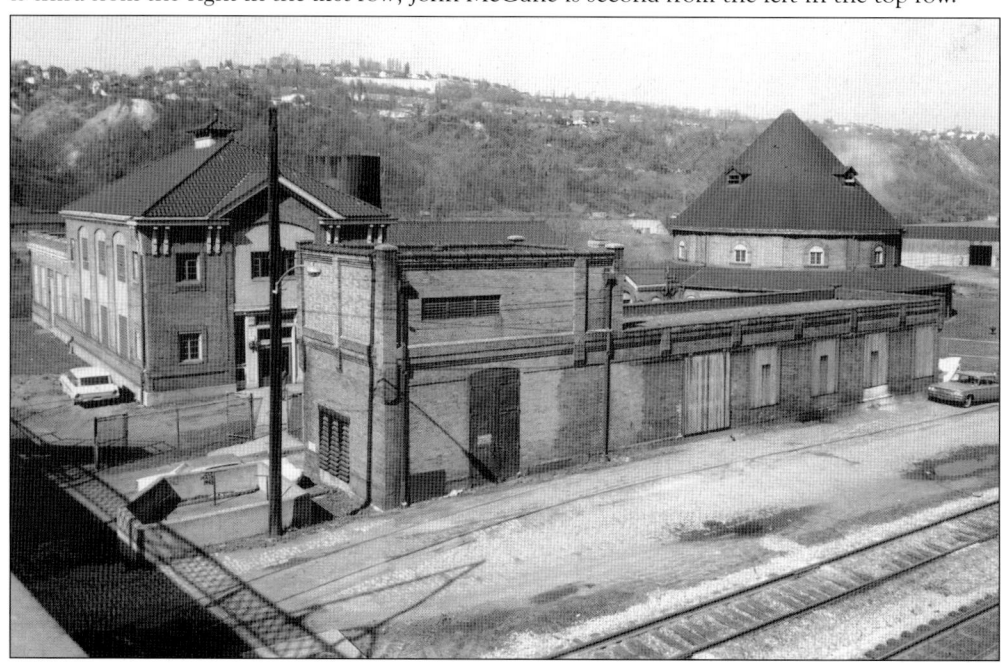

The water filtration plant was a plumber's paradise because the water ate the pipes and fittings. On October 11, 1908, a state-of-the-art treatment plant, designed by Alexander Potter of New York, was opened. The following year, it pumped one and a half billion gallons. Consumer cost was 10¢ to 26 2/3¢ per thousand gallons.

Originally called the Bank of McKeesport, McKeesport National Bank was organized in 1887. Now on the historical buildings registry, this structure was erected in 1889 at the corner of Fifth Avenue and Sinclair Street. The photograph here was taken in 1954, and much of the exterior remains the same. In the era of bank mergers, it had several different names. The building was recently acquired by the city from Sky Bank and is now home to the McKeesport city offices.

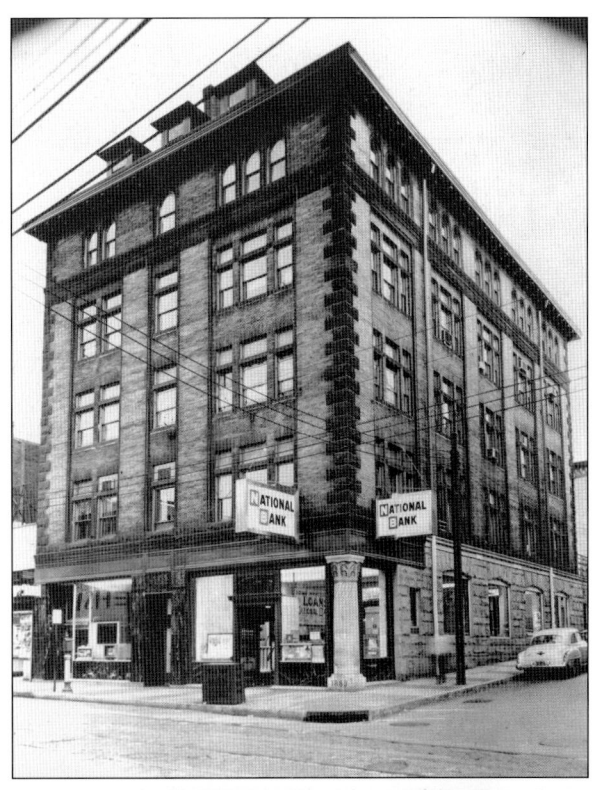

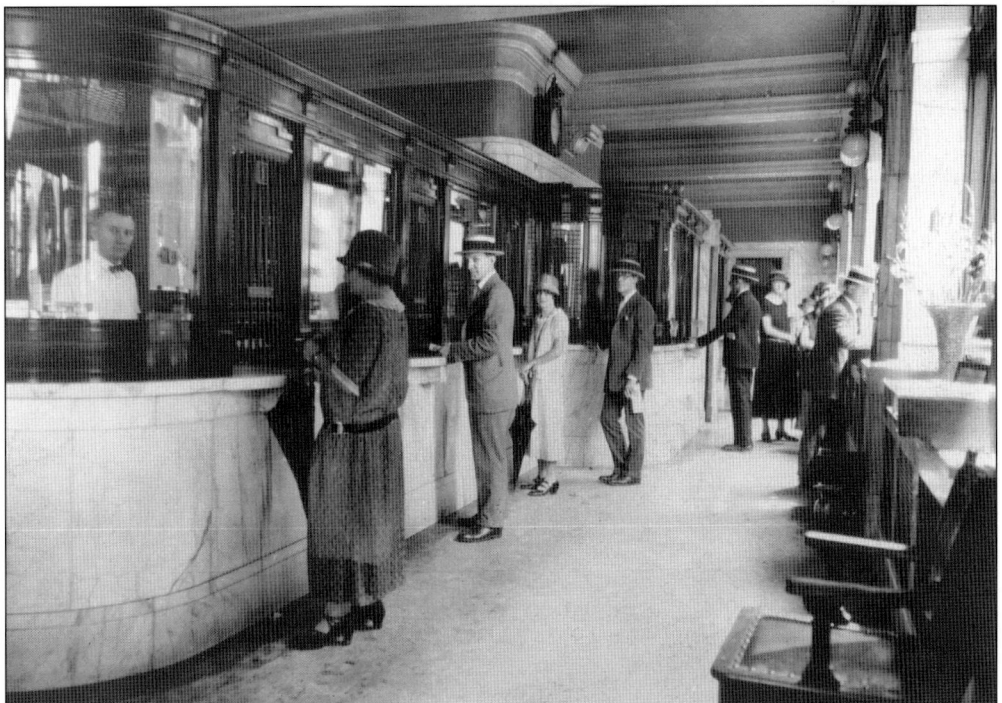

This 1920 photograph of the interior of McKeesport National Bank illustrates the fashion of the day.

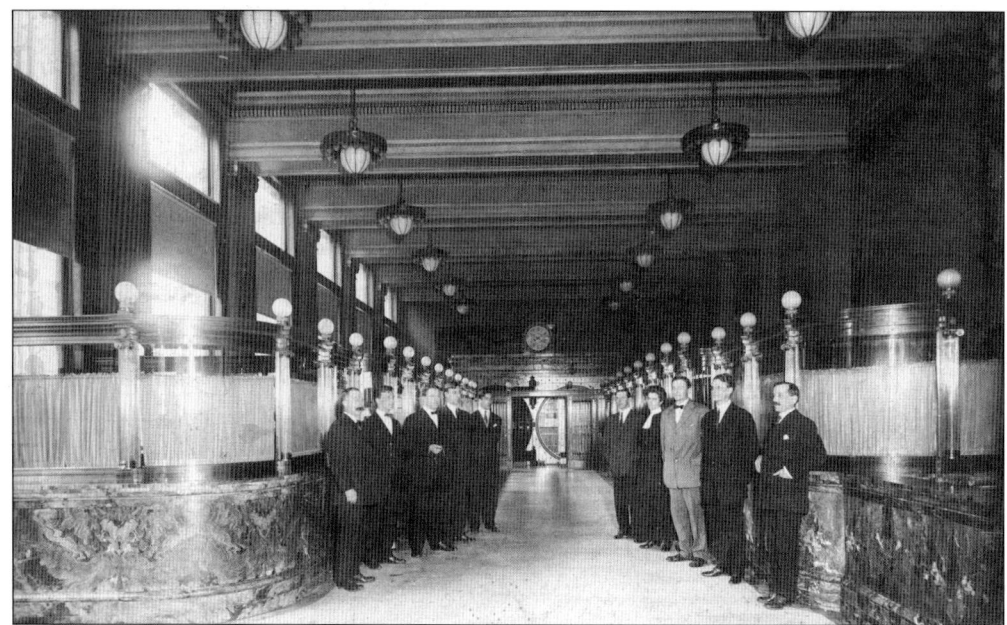

The Peoples Bank of McKeesport was organized in 1873 with J. C. Converse as president and capital stock of $100,000. Originally located on the corner of Fifth Avenue and Market Street, it moved in 1907 to a new building on the corner of Fifth Avenue and Walnut Street. This interior view shows the ample use of brass and marble, making it one of the most beautiful buildings in the city.

Considered a landmark business in the McKeesport area, Hiawatha Drug Store moved in the 1920s from the White's Opera House building to 509 Walnut Street.

The Harold Blid Pharmacy, located on Ringgold Street between Locust and Sinclair Streets, was a bustling business for many years. Downtown shoppers often dropped a prescription off at the pharmacy before frequenting all of their favorite businesses in town. Note the side entrance of the YMCA on Ringgold Street. The YMCA building still stands and houses active YMCA programs.

John Charney, right, was a barber for 54 years. The shaving mugs behind him were ordered from New York for $2 each. They bore the names of the customers. Out of fashion at the time of this 1944 photograph, he kept them as mementos of past years. Charney came to the United States in 1887 and to McKeesport in 1891. He worked in the mill for 11¢ an hour and then became a barber to pursue a safer occupation.

For many people, going to the market meant a daily walk to Olender's Fruit Market on the corner of Bailie and Evans Avenues. In this 1927 photograph, Sam Finkelstein holds a squash while Ruth and Bennie Olender smile for the camera.

Family-run grocery stores were located in neighborhoods throughout the city and were within walking distance, making shopping easy. Stanley and Helen Grebeck operated a neighborhood market on Grover Street for 45 years. At Grebeck's, meat was cut to order and fruits and vegetables were the freshest. They even delivered. This photograph shows Stan C. Grebeck, on leave from the army in 1951, donning an apron and pitching in to help at the family business.

J. Kausch Bakery was founded in 1904 and was located at 1403 Soles Street. The bakery had a gas-fired brick oven. During the 1936 flood, springwater was carried to the bakery by Kausch's sons so that they could bake bread for the stricken city. The bakery was sold in 1950.

The Jordan Banana Company trucks shown here were familiar sights in McKeesport. Founded in the 1880s by Italian immigrant Rafael Giordano, the company has been passed down through generations and is still owned by descendants of Giordano. Opening on Jerome Street, it later moved to O'Neil Boulevard and then to its present location in Dravosburg. Originally opened as a banana wholesale and distribution business, it later expanded to include all fruits and vegetables.

This photograph from around 1900 shows the horse-drawn delivery wagons for the National Biscuit office in McKeesport, located at the corner of Seventh and Walnut Streets. It later moved to the corner of Peebles Lane and Tenth Street, and then to Versailles in the Schwebel's Bakery area. The building on the left is the Dulaney grocery warehouse, later called the Patterson and Warren warehouse and then Ruben Furniture warehouse.

Located on the corner of Twelfth Street and Walnut Street, the Tube City Brewing Company opened in 1904. At that time, there were five breweries in McKeesport. During Prohibition, most closed down or depended on offering cold storage to survive. Tube City Brewing Company closed in 1955.

This late-1940s photograph shows the Fifth Avenue location of G. C. Murphy Company 5 and 10¢ Store. McKeesport was the national corporate headquarters of Murphy's, which was started in 1906 and bought out by Ames in 1985. At one time, there were three G. C. Murphy stores in McKeesport proper. Murphy's Restaurant was a popular place for lunch and, at Christmas, Santa always visited for breakfast with the youngsters.

This early-1900s photograph shows patrons at the Nizinski Hotel and Bar, which was located at 1227 Fifth Avenue. George W. Nizinski was born in 1872 in Poland and immigrated to the United States at the age of 15. He held numerous labor and bartending jobs until purchasing his hotel and tavern in 1914.

41

Lippert's Café was another popular eating place in town. It was originally across Walnut Street from the *Daily News*. Later it was relocated to Ringold Street.

Waiting for the bus could be a great deal more tolerable because of the presence of the waiting room, where one could purchase a treat, a newspaper, magazine, or even a toy to enjoy on the ride home.

Bukes Candy-Ette was a popular place to buy candy, but one could also relax and enjoy ice cream at the fountain. A regular stop for teenagers, it was next door to J&R Meat Market. Note the 1960s prices for meat.

Wivagg Printing Company started as the *Daily News* job shop. It was bought by Hutchison and Broadbent and run by them until Broadbent left to be a farmer. He sold his share of the business to Elmer Wivagg. Upon his retirement, his son DeWayne Wivagg ran the business for many years. He sold the business to new owners who have kept the Wivagg name.

When McKeesport's downtown was bustling with business, the Club Car Diner was a popular eating establishment. Many workers and shoppers "did lunch" at the diner. It was the place to meet for breakfast after the bars closed at 2:00 a.m.

The Union Clothing Company was established in 1916 by Morris H. Levine in one small room above Woolworth's. Highly successful, it expanded to an entire floor in one year. Here in 1921, ladies pause for a photograph in the sewing room at the new location in the Ruben building at 225 Fifth Avenue.

The Famous Department Store at Fifth Avenue and Market Street was one of the major McKeesport businesses for years. These photographs show the original building and the remodeled store. The building burned to the ground in 1976 in the great McKeesport fire often referred to as the "Famous fire."

45

Originally a livery stable, Hunter's provided a horse and buggy for $1.50 or $2 a day. The building later became Hunter's Garage. Here in 1937, the space is occupied by a Buick dealership, which provided Atlantic gasoline.

This 1914 photograph was taken inside the W. W. Hunter Livery Stable at 129 Market Street. Seen here, from left to right, are Doc Martin, Billy Smith, and Frank Rhoades.

46

Jaison's was a popular department store in McKeesport specializing in shoes, clothing, and accessories. Shoppers are shown here in 1970 taking advantage of bargains at a rummage sale.

The Sabin China Company was founded by Leonard Berkovitz and Sam Sabin in the late 1930s. Known for manufacturing and decorating fine china, it started in a small shop on Fifth Avenue and later moved to Juniper Street in Versailles Borough. One section of the plant was devoted solely to lining the rims of plates with 18-karat gold. The showroom displayed giant piggy banks and cookie jars. In 1967, the business was sold, and it closed in the 1970s when it was destroyed by fire.

The first edition of the *McKeesport Daily News* was published on July 1, 1884, on one of the old-style cylinder presses. Harry S. Dravo and Wesley Dravo were the organizers who chose F. B. Clark as the editor and J. L. Devenny as the reporter. It later became the *Daily News* and was owned and operated by the Mansfield family. The Miles Publishing Company recently purchased the paper. It is the only daily paper in McKeesport.

Minerva Bakery on Fifth Avenue, a family business started more than 80 years ago, was founded by George Monezis, a Greek immigrant born in 1887. First located on Walnut Street, it became and remains a McKeesport favorite. At Easter time, crowds stand in long lines to purchase Minerva's famous paskas.

Three

COMMUNITY SERVICES

Every city has a group of services that are considered vital to the area's citizens. Most focus on protection, safety, health, education, and general welfare and are instrumental in the protection of the people and property of the city. Some of the services represented here include police, fire, hospital, library, and the postal services. They are not always used on a daily basis, but knowing they are available when necessary provides a sense of security.

Loosely organized in the beginning, fire protection was done on a volunteer basis in the 1870s. The first paid fire department started in 1885. This 1920s photograph shows firefighters at the No. 3 station on Evans Avenue.

Shown here are firemen checking out equipment in the 1930s. Engine Company No. 2 had to be ready to respond in an instant with men and machines. Note the dirt street in front of the fire station.

Fred Bray was hired by the McKeesport Fire Department in 1968. In November 1994, he was appointed fire chief and was the first African American to serve in that capacity. Bray retired in 2005 after 36 years of service with the department.

Continuing the trend of firsts in the Bray family, Faith Baldwin Bray, wife of Fire Chief Fred Bray, was Allegheny County's first female African American police officer. She was hired in September 1979.

The 1909 McKeesport Police Department is shown here in front of Central Police and Fire Station.

This 1954 photograph shows the Central Police and Fire Station located on Market Street and Fourth Avenue. (Today Market Street no longer crosses the railroad tracks pictured in the foreground.) The buildings along this section of Market Street, including the Gemilas Chesed synagogue, were demolished to allow for expansion of the National Tube Works.

McKeesport city traffic inspector William Tomko is shown teaching children about safety at crosswalks on city streets. The officer was known as "Tomko the Fearless."

In 1951, Mayor Charles Kinkaid developed a corps of crossing guards to protect children on their way to and from school. Shown here, from left to right, are Chief of Police Walter Lofstrom and guards Edith Robis, Helen David, Lottie Slaney, Virginia Ero, Ann Kobulnicky, Helen Germek, Catherine Halvin, Mrs. Chontos, Grace Dolata, Rita Hyduk, and Margaret Clark.

A customer hurriedly crosses the windy corner of Walnut Street near the old post office. Is that a babushka she is wearing? Walnut Street School is pictured in the background.

Shown here in the early 1900s, proud employees stand in front of the old McKeesport Post Office. Postmaster John Dersam stands in the middle of the second row.

The McKeesport-Versailles Cemetery was established in 1856. The cemetery has two entrances; the main entrance shown here is on Fifth Avenue, and the other entrance is on Versailles Avenue. The city's founding fathers and their families were laid to rest here. There is a special section paying tribute to McKeesport's Civil War veterans. The building on the left is no longer standing.

In 1899, Andrew Carnegie notified the Women's Club of McKeesport that he would contribute $50,000 for a library as long as the citizens provided a suitable site and at least $3,000 annually for the upkeep. The James Evans and Oliver Evans estate donated the 1.5 acres of land at the corner of Union and Carnegie Avenues where the library still stands.

McKeesport Hospital was organized in 1890. Construction was finished in 1894, and the hospital opened for business on April 18, 1894, with 185 beds. Over the years, with the addition of the Shaw and Crawford wings, the capacity expanded to 600 beds. The "Old Main" building was razed in 1955. The hospital is now part of the University of Pittsburgh Medical Center.

A creative photographer took this photograph from the rooftop of the "Old Main" building of McKeesport Hospital. The building in the background is the Painter Memorial maternity building where most McKeesport-area residents were brought into the world.

Four
Schools and Churches

The Bible and the almanac were the only books to be found in McKee's Port homes in the early years. Survival was most important, and the first teaching was done largely at home only as time permitted. The first schoolmaster was hired in 1816, and the first school was built and supported by private subscription in 1832. Serving religious needs of settlers primarily English and Scotch-Irish, the early churches were Protestant, with First Presbyterian being the first to be built in town, followed by Baptist, Lutheran, and other denominations. As industry grew in the mid-19th century, workers were needed, and many came from Hungary, Czechoslovakia, Poland, Italy, Yugoslavia, Ireland, Sweden, Greece, and Germany. Soon churches and synagogues representing countless denominations and ethnicities were built in neighborhoods around the city.

Growing neighborhoods spurred the development of public and private schools in almost every ward. Many of the parochial schools reflected the ethnic nature of the neighborhood. The high schools were mainly public, and most McKeesporters can recall the smell of chalk dust and mimeograph fluid as well as some terrific teachers who wore sensible shoes and demanded and received respect in the classroom.

In 1832, the first schoolhouse was started by private subscription. Fourth Street on the west side of the public square was chosen as a building site. Squire Joseph Wampler was selected to construct a frame building that was 20 by 30 feet. This was the first schoolhouse in the area, and many local residents received their first lessons within its walls.

Back in 1872, Jack's Run School was built in Versailles Township at the intersection of McClintock Road and Route 48. Students in grades 1-8 attended this one-room schoolhouse heated by two pot-bellied stoves. It was torn down in 1930.

History does not say if Miss Christy was the only teacher for the student body of Bryn Mawr School in 1914. A very young Thelma Dulany is in the third row in a white tassel cap.

Shaw Avenue School was originally built as a high school. Located at the corner of Shaw Avenue and Locust Street, it eventually housed ninth-grade students. Prior to being razed, it was an elementary school.

South Park School, an elementary school, was located on Evans Avenue. In 1916, the graduation ceremony was held at White's Opera House and Albert Fallquist was one of the students in Room 11. The school was razed in 1962, and townhouses were built on the site.

When it was built in 1880, Walnut Street School was referred to as Walnut-Second Ward School. It originally housed a high school, which graduated 10 students in 1884. The building to the left of Walnut Street School is Ninth Street School, which was built in 1890. Both buildings were razed in 1963. The new post office is located on the site of Walnut Street School.

In 1913, a large hair bow was the height of fashion and the girls in this second-grade class at Fifth Avenue School were right in style.

This area has always prided itself on its sports teams. Pictured is the 1946 Port Vue Junior High School football team. Many of these athletes went on to play high school football.

Students in front of Myers Street School in Port Vue pose for this photograph around the 1920s. As one can see, knickers were the uniform of the day for the boys, along with high-button shoes.

Seen here is one of three first-grade classes at Centennial School in 1953. Dorothy Porter was the teacher, and Walter Larson was the principal.

The building remembered fondly as "Voc" was the location of all of the programs then referred to as vocational. Graduates from Voc were prepared to go into the workforce in many trades, such as bricklaying, auto mechanics, and drafting. It was also the place to cheer on the varsity basketball team. The building has recently undergone extensive renovation and is now called Founders' Hall. It houses seventh- and eighth-grade classes for the McKeesport Area School District.

This is the 1946 Junior Auto Mechanics class of Vocational High School. Some of the students shown with the instructor, Howard J. Fox, are John Monteremes, John Torrance, Samuel Hummel, John Otobra, Steve Sabo, Paul Leaver, George Schreiner, Elmer Kline, Jimmy Nehase, Robert Matwich, Herb Lichenstein, Russell Fawcett, and Richard Forsythe. The others are unidentified.

The 1943 McKeesport Technical High School marching band is pictured on the bleachers of War Memorial Field, the site of many football games and high school graduations. After McKeesport Area Senior High School was completed in 1960, this building became known as McKeesport Junior High and later, Cornell Middle School. The stadium has since been razed.

This is a McKeesport Area School Board meeting in 1958. Seated around the table, from left to right, are Chester Knauss, Dr. Robert Heft, Margaret Larson, Harold Blid, William Morgan, Charles Kearny, David Shermer, J. Paul Farrell, and Dr. Clifford Bryce. The picture on the wall is of Dr. James H. Lawson.

Boys from Vocational High School, and future taxpayers, gather in the Elks auditorium to watch the inauguration of Pres. Dwight D. Eisenhower on January 20, 1953. Television was still relatively new in the early 1950s, so this was a rare event.

Here is a wintry welcome to Penn State McKeesport. After offering coursework for veterans at various locations in the area, the current site opened in one building in February 1959. For many years, it served as a feeder campus to University Park, offering associate degrees and the first two years of a bachelor's degree. The location now boasts nine buildings and offers five baccalaureate degree programs.

The First Presbyterian Church of McKeesport is the oldest organization in the city, secular or religious. It was founded prior to 1798 and was instrumental in the organization of the Presbyterian churches in Dravosburg and the Cumberland Presbyterian (later the Second Presbyterian, which merged with the Central Presbyterian). The building was also used as an early polling place.

Seen here is the First Presbyterian Church as it looks today.

Amity Presbyterian Church was built in 1871 on Washington Road in Dravosburg. This church was named after the village of Amity, which was near Dravosburg. It started as a Sunday school and was organized into a church on August 4, 1886.

The original St. Peter's Church and School was located on Market Street, as shown in this 1894 photograph. It was renamed St. Martin de Porres as a result of a diocesan merger that joined together the parishes of St. Peter's, Holy Trinity, and Sacred Heart.

First Methodist Episcopal Church was founded in 1841. The congregation first worshipped in homes, then in a redbrick building at the corner of Market Street and Fifth Avenue. In 1876, the church moved to a building at the corner of Walnut and Penney Streets; this building served the congregation well until 1924 when it burned down. This is the original building of the First Methodist Episcopal Church on Walnut Street.

Ground was broken in 1925 for a new First Methodist Episcopal Church building at the corner of Cornell Street and Versailles Avenue. Dedication took place on November 21, 1926. United Methodists continue to worship at this location.

The Tabor Lutheran Church stood on the corner of Jenny Lind Street and Evans Avenue, where it was dedicated in 1922. The church was originally founded in 1887. It was merged with Calvary Lutheran of White Oak and Trinity Lutheran of McKeesport in 1972 to become Faith Lutheran Church of White Oak.

This is the Faith Lutheran Church of White Oak as it appears today.

The Bethlehem Baptist Church was organized by Rev. Thomas Ford on October 20, 1889, with 15 members and Mr. Courtney as pastor. In 1896, the lots were purchased where the present church stands at 716 Walnut Street.

Gemulas Chesed was the Jewish synagogue located at Market and Third Streets in the 1st Ward. It moved to its new location on Summit Street in White Oak, where the spelling of the name was changed to Gemilas Chesed. The synagogue maintains an active congregation.

The social life of many families centered around church activities. In April 1922, the Junior Missionary Society of the Swedish Lutheran Church presented a pageant, "Children of Many Lands."

St. Stephen's Roman Catholic Church was founded in 1899, and the building still remains on Beacon Street. In a day when churches were very ethnic, the congregation was made up of Hungarians from many towns in the local area. The wood for this ornate altar was imported from Hungary, and the men from the parish handcrafted all the woodwork, creating niches for all the saints. The last mass was celebrated on July 7, 2002, when the congregation merged with St. Pius.

Sr. Patricia Jordan is shown with the 1937 graduating class of St. Stephen's School.

First communion was a special day for seven-year-old students attending the Catholic schools. Shown here in 1936 is the First Communion class of St. Mary's Polish Church on Versailles Avenue. Following the closure of many Catholic schools in the 1970s, St. Mary's school became Central Catholic School until its closure in June 2003.

This photograph is from a play put on for the congregation of the Trinity Evangelical Lutheran Church on Palm Sunday in 1942. Shown from left to right are (first row) Bill Luptak, Robert and Judy Barkemeyer, and an unidentified young girl; (second row) Naomi B. Pastrick, Pearl McDonald, Joan Ryan Tellman, Irene Little, Mildred Yost, Eleanor Kratzer, Betty Carlson, Charlotte Vance, and Mrs. Kieffer.

McKeesport's Italian population will remember the sanctuary of the original St. Perpetua Roman Catholic Church on Ridge Street. A new church was constructed on the corner of Thirty-second Street and Rockwood Avenue in 1962 to be closer to the Italian community. When many of the area's Roman Catholic churches were merged, St. Perpetua joined the parishes of St. Patrick's Mission Church of Coulter and St. Dennis of Versailles to become St. Patrick Roman Catholic Church.

There were a lot of very natty dressers in the June 1939 graduating class of St. Pius Roman Catholic School. Stylish hats and white knickers made for an impressive picture.

When it opened in 1908, St. Mary's German Catholic Church on Olive and Locust Streets was described as magnificent. Patterned in the early Christian basilica style, it contained beautiful murals hand painted in a Beuronese style. In 1993, due to shrinking membership, the Catholic Diocese of Pittsburgh merged four McKeesport churches. Vacant for four years, the building was demolished in 1997, but not before the murals and other interior items were auctioned off or otherwise distributed to other churches and parishes.

Five
CLUBS, ORGANIZATIONS, AND CULTURE

Early life left little time for fraternizing and culture, but as the city grew, people joined together. The first recorded organizations were fraternal, beneficial, benevolent, and all male. Many were secret societies such as the Masons. Later, groups emerged from the ethnic communities, including the German Turners, the Ancient Order of Hibernians (AOH), and the Swedish Singing Society. Nationality-based social halls were commonplace. Fraternal orders such as the Elks, Eagles, and Knights of Columbus were established later. Many women's groups came into being in the early 1900s. In the mid-20th century came development of garden clubs, the little theater, and the symphony. The McKeesport Heritage Center, dedicated to preserving the rich history of the area, was founded in 1980.

The McKeesport Kiwanis was started in 1921 with a membership of 85. Kiwanis district governor Jim Richards came to McKeesport in 1975 to present Legion of Honor awards to members of the McKeesport Kiwanis Club who belonged to the club for 25 years or more. Sharing a lighthearted moment are, from left to right, members Raymond Chute, Richards, John Laughlin, J. Charles Peterson, and Wilson Baum. The Kiwanis Club remains an active organization continuing its mission to raise funds for youth services.

McKeesport Lions Club was chartered on July 13, 1922, with H. J. Lohman serving as the first president. Sidney A. Kaplan served the McKeesport Lions Club for over 40 years as secretary. In this 1947 photograph, members celebrate the club's 25th anniversary. Kaplan is shown in the center of the photograph. The Lions Club continues as a major service organization committed to vision-related volunteer work.

The McKeesport Rotary Club was chartered in 1914. Rotary is an organization of business and professional leaders dedicated to providing good will and peace. The McKeesport Rotary Club recognizes attendance by individuals. Good will is shown here as members of the club held a meeting at McKeesport Hospital to guarantee patient Elmer Wivagg's perfect attendance.

The mission of Toastmaster's International is to provide members the opportunity to develop communication and leadership skills. Members of Club 901 from McKeesport are seen here enjoying the stories of one of their speakers. Calvin Clark is on the left. Laughing at the podium is Frank Neish, and to his right is Bill Craig Sr.

77

The members of the Syria Shrine are all smiles in their well-recognized hats as they work on their next project. The Shriners organization believes in the spirit of having fun and providing the resources of its great philanthropy to Shriners Hospitals for children nationwide. Members of the local temple shown seated here, from left to right, are Ken Paxton, C. E. Palmer, Walter Soles, and unidentified; standing is C. Noll.

This 1956 photograph shows officers and members of the Alliquippa Lodge No. 375 of the Masons. Started in 1866, the first officers were Eli A. Wood, W. E. Harrison, William B. Junker, and William Hill. The idea for a lodge in McKeesport arose one cold winter evening when McKeesport residents were returning home after a meeting in Pittsburgh. Cold and wet after a horse-and-buggy ride, one asked "Why don't we have a lodge in McKeesport?"

The McKeesport Boys Club guided the children of McKeesport and surrounding areas. Officers and board members shown in this 1950s photograph, from left to right, are (first row) president Samuel LaRosa, treasurer Robert M. Baldridge, William McGibbeny, and vice president Dr. J. C. Kelly; (second row) Lou E. Fordan, Mayor C. A. Kincaid, and Judge Samuel A. Weiss.

The 6th Ward EBA Club was one of many clubs started in neighborhoods or wards by men looking for a place to get together after work and have a drink and share stories. The EBA was originally located on Evans Avenue. When members were queried about the name EBA, they would laughingly identify it as the "Ear Benders Association" or the "Elbow Benders Association." Here members shed their work clothes and dress up to attend their annual banquet.

Seen here is an image from Veteran's Day in Port Vue in 1953. Robert Locke, commander of the American Legion Post 447, is presenting a flag to burgess Adolph Jacobyansky. From left to right are Andrew Mihalek, post chaplain; legionnaire (and councilman) Charles Grback; Locke; legionnaire (and councilman) Edward Welch; Jacobyansky; and John Dorsey, post senior vice commander. This memorial was replaced by a street-level monument in November 1992.

McKeesport's Benevolent Protected Order of Elks (BPOE) was organized on September 26, 1889, and its lodge was opened in 1905 on Market Street. The estimated cost of the building and furnishings was $88,000. The building contained club rooms, billiard rooms, bowling alleys, a banquet and dancing hall, and ladies' and gentlemen's parlors and was decorated with flags in honor of its 50th anniversary. The building was destroyed by fire and remains a shell today.

Started around 1890, the Swedish Singing Society of McKeesport was an organization of talented singers that held concerts throughout the country. Part of the American Union of Swedish Singers, they participated nationally and were considered one of the premier Swedish singing groups in the country and showcased their talent at the Swedish Exposition in Stockholm in 1896. The society was located in a blue tile building on Shaw Avenue. This photograph is from the early 1900s.

The Daughters of the American Revolution (DAR) accepts women who can trace their ancestry to patriots who fought in the American Revolution. This photograph shows members depicting an event called the George Washington Tea.

McKeesport Business and Professional Women started on November 25, 1930, when 40 members signed the charter. Irene Atwater was one of the first members and president from 1940 to 1944. Some of the early projects included establishing the Visiting Nurses Association and assisting in the presence of the Mon Yough Mental Health and Mental Retardation Services in the city. Every year, scholarships are given to high school seniors.

The Semper Fideles Club was organized in 1919. Annie Marshall, the founder and first president, explained at the original meeting that the purpose of the club was to do local charitable work. Shown here attending the Human Relations Tea in 1967, from left to right, are (seated) Katherine Dix, Adell Long, Catherine Still, M. Jeanne Dix, and Virginia Gittens; (standing) unidentified, Yvonne Lanauze, Rubye Hadley, Gertrude Bolar, Helen Brown, Mildred Peyton, Hazel Garland, and unidentified.

In the early 1900s, a male Kiwanis member started Altrusa to give professional women a similar organization. Altrusa International Club of McKeesport, chartered in 1941, has for years supported the community both financially and through service projects. These Altrusans were attending the Heart Ball, which supported the cardiac unit at McKeesport Hospital. Pictured are (first row) unidentified, Eleanor Kratzer, Marie Race, Hazel Garland, and Mary Jane Webster; (second row) Valeria Cramer, Marjorie Smith, unidentified, and Fran Kittiko.

Gathered around the table are proud members of the McKeesport College Club. Pictured are (seated) Vivian Bowles Gessner, Ruth Richards, Ann Camic, Dorothy Pollock, and Jane Boughner; (standing) Mary Lutes, Ruth Kearney, Martha Wiggins, Lois Anderson, Eleanor Beresford, Barbara Meredith, Martha Ann Brown, and Dorothy Leuhm. McKeesport College Club was founded in 1921 for the purpose of uniting college women of the community for educational work and sociability.

The Young Men's Christian Association (YMCA) was formerly located at the corner of Shaw Avenue and Locust Street. Presently located at 523 Sinclair Street, it boasts a coed health club and swimming pool. Many area youngsters learned to swim at the YMCA during the Kiwanis "Learn to Swim Campaigns" every spring.

On November 4, 1959, founder Mihail Stolarevsky lead the McKeesport Symphony in its first concert at the Memorial Theater. Since the early 1960s, concerts have been held at the McKeesport Senior High School auditorium. Originally an amateur group, the orchestra currently includes 50 musicians, most of them professional.

McKeesport Little Theater was founded in 1960 by Phyllis Braveman. Shows were held in various locations until a vacant church at the corner of Penny and Jenny Lind Streets was purchased. As a result of a fire at the theater, it moved to the Versailles Elementary School, and then to its present location on Coursin Street. Shown here rehearsing for *The Tender Trap* are P. J. Gallagher, Mary Pforsich, and James Kunkle. The director, Phyllis Braveman, is on the right.

The Garden Club of McKeesport has continued to maintain the rose garden in Renzie Park since it started in 1938. The public garden and arboretum has over 1,800 rose bushes in 40 beds. It has expanded to include other perennials and a beautiful water garden. Numerous weddings are performed in the gazebo in the center of the rose garden. Volunteers from all over the region gather on Wednesday mornings to prune, weed, deadhead, and weed some more.

The McKeesport Heritage Center was founded in 1980 by Frank Kelly and a group of people interested in preserving the history of McKeesport. The center started in one room at Penn State McKeesport and is now in Renzie Park. The center showcases many collections and is an epicenter for genealogy research.

Six

Parks

Three parks played a central role in McKeesport's history. Renziehausen Park was the "front and back yard" of the city with its space for band concerts, picnics, football practice, softball games, dog walking, fireworks, swimming, or just "hanging out." Rainbow Gardens had rides, a drive-in, and a large pool. Most do not remember the amusement park that once stood where the Olympia Shopping Center is now, but it boasted an inn, rides, and a lake for boating. It closed when Route 48 was built through there. Kennywood, although located near Duquesne, is familiar to many as the place where school picnics took place.

The pre–Civil War Greenewald home was located in Renziehausen "Renzie" Park. With its wraparound porch, barn, springhouse, and stable, it was the residence of Herman and Emma Greenewald. Milk from their herd of cattle was taken to dairyman Weinberger, whose business was on Ninth Street. The property was valued at $8,000 in 1932. In 1962, it cost $741.36 to demolish it.

The Nettie L. and Robert E. Stone Memorial Swimming Pool at Renzie Park was the favorite place to cool off during hot summer days. Residents could purchase season passes, and young people "lived" there all season, feasting on favorite snack bar treats.

Renzie Bandshell, donated by the McKeesport Lions Club, was fashioned after the Hollywood Bowl in California. It has long been the site of many summer concerts and presentations. This Labor Day concert on September 7, 1959, was performed by members of the United States Air Force and the Women's Air Force Band. The city recreation board continues to offer a summer concert series on Sunday evenings.

Ice-skating fun continues in Renzie Park at Lake Emilie. Here in 1959, some local young men try their skills in ice hockey long before the Pittsburgh Penguins came to town.

89

With a crude fireplace made from a 50-gallon drum, Nancy Beall (left) and Margie Bryan (right) warm their hands after ice-skating on Lake Emilie in Renzie Park.

The City of McKeesport Recreation Department continues to sponsor fishing contests at Lake Emilie. The lake is named after Emilie Renziehausen, who left the funds for the establishment of the lake.

In the 1950s and 1960s, there were many activities and contests held in Renzie Park under the direction of Edith Robis, McKeesport recreation supervisor. This young lady was in a tap dance contest.

Held in April, one of the events organized by the recreation department at Renzie Park was the annual kite flying contest. These young men are shown holding their winning kites and their trophies. This was the kind of activity keeping youngsters busy in 1959.

McKeesport is a ball-playing town with baseball and softball organized and played at all levels. Many may recall playing on the Helen Richey and Jimmy Long fields. In 2005, two new ball fields were constructed and dedicated in the park. Shown here at the dedication, Mayor Jim Brewster recalled his own ball-playing days in his youth.

The bocce court is one of the newest additions to recreational facilities at Renzie Park. Located near the senior citizen's center, it provides a new opportunity for fun and camaraderie.

The old refreshment stand no longer serves food. It is now an active gathering place for McKeesport's senior citizens where members gather to play cards, watch television, plan outings, or just shoot the breeze.

Enjoying the "lazy, hazy days of summer," seniors experience the easy life as they relax outside the senior center in the park.

Since 1960, the city of McKeesport has hosted International Village in mid-August. An ethnic food and dance festival, the "village" as it is affectionately called, is a McKeesport tradition. Carrying on the tradition of their countries of origin, the local churches still provide the food for sale. The food, ethnic entertainment, fireworks, and activities bring thousands of visitors from all over to Renzie Park every August. Shown here are tiny Polish dancers.

Good eating is seen here at the German booth.

Free at last! Pictured here is the Ukrainian booth at International Village.

Folks are pictured waiting for apple strudel and lamb sandwiches at the Serbian booth.

95

These hungry residents are in line for Greek gyros and honey balls.

Does anyone know if it is spelled Pirogi, Pirohy, or Pierogie?

McKeesport High School cheerleaders jump with joy as they perform for the crowds at International Village.

Much of the work done to beautify the environment and structures in Renzie Park was provided by the Works Progress Administration (WPA) workers in the 1930s. This photograph shows a crew of such workers. The men in suits, ties, and hats may have been foremen.

97

The bathhouse at Rainbow Gardens Pool is the backdrop for a line-up of athletes, bathing beauties, and maybe even a lifeguard or two in this 1920s postcard.

This group picture was taken at Olympia Park in Versailles Borough. Olympia boasted an amusement park, picnic area, Rollerdrome, boating lake, and Danceland. The park operations ceased in 1942. The lake was drained, and Long Run Road (Route 48) was built.

Seven
Memorable Events

In recent news, stories have been told of horrific disasters that destroy lives and property the world over. McKeesport has been spared from disasters for the most part but has not been totally unscathed. Perhaps the most devastating event in the city's history was the blaze referred to as the "Famous fire," named for the Famous Department Store where it started. There have been other fires that destroyed businesses, but theater lovers were disheartened by the fiery destruction of McKeesport Little Theater in 1972.

Situated at the confluence of two rivers, periodic flooding plagued the city. The floods of 1936 and 1972 were truly memorable. The good news is that McKeesporters do not have to be concerned about the hurricanes and earthquakes or forest fires that plague other parts of the country.

In 1956, the Menzie Dairy Garage was hit by a devastating fire. The garage was on Walnut Street in the Christy Park area. It housed the trucks that made home deliveries. The dairy itself was located on Riverview Avenue in the 7th Ward of the city and closed on November 1, 1976.

The Stone Furniture Building burned on June 10, 1963. Lightning was blamed for destroying the top two floors in 1953, as well as in the 1963 blaze. The building housed Wander Sales, Shulhof Tire Company, and Stone's, whose slogan was "Try Stone's for soft beds."

The Famous Department Store, located at 514 Market Street, burned in a fierce blaze in May 1976. Loss was in excess of $4 million. The fire engulfed the store within five to seven minutes. Fortunately, no lives were lost. The flames forced nine businesses to close, including the Memorial Theater. McKeesport Fire Department was assisted in fighting the fire by companies from Duquesne, Clairton, and Pittsburgh, as well as over 50 volunteer companies.

McKeesport Little Theater was situated at the corner of Penney and Jenny Lind Streets from 1962 until it was destroyed by fire in April 1972. The fire started at the adjacent vacant Calvary Methodist Episcopal Church and spread to the theater. The theater was in the middle of a run of *The Sound of Music*, but opened the following weekend at the Elks Lodge. It continued to perform at Versailles Elementary School until it purchased the Tree of Life Synagogue in 1974.

The St. Patrick's Day flood in 1936 was one of the most destructive in the region. Floating by the Hotel Herman at the corner of Market Street and Thirteenth Street are two men on a makeshift raft. The proprietor of the hotel was Herman Marwitz.

During the flood of 1972, high water levels reached the first floor of Tile City, which was located on the first level of the Palisades Building on Fifth Avenue and Water Street.

Eight
Familiar Faces

There are familiar names and familiar faces, and although many names are recognizable, their images are unknown. Familiar names like Queen Aliquippa and the McKee family date back to the 1700s before photography was available. Some people were not amenable to being photographed, but many early names still exist in the city through its streets, bridges, and buildings. Included here are faces of some of the heroes, playwrights, local politicians, educators, and national figures who have visited the city. Many familiar faces are found throughout the book, but these are some of the most memorable.

The Waters family, who moved from Maryland to Versailles Borough in the 1920s and later to Christy Park, posed for this portrait in their Sunday best. From left to right, they are Oratheus, Ida, Ruby, Sam, and Roger. Sam came to the area to work for U.S. Steel.

Mitchell Paige, a United States Marine, was taught by his mother never to forget his Serbian roots, but to always be thankful for the privilege of living in America. He became an American hero during the battle for Guadalcanal in 1942 and received the Congressional Medal of Honor for his bravery. In 1998, Hasbro Toy Company released a classic collection G. I. Joe figure of "Mitch Paige."

Growing up on Jenny Lind Street in the early 1900s, Helen Richey was the daughter of school superintendent Dr. Joseph Richey. He wanted her to be a teacher; she wanted to fly. The first woman copilot for a commercial airline, she held many flying records. She flew for the British Air Transport Auxiliary and the U.S. Women's Air Service Pilots (WASP). Among Helen's flying friends were Jacqueline Cochran and Amelia Earhart, who declared her the nation's greatest aviatrix.

The Garlands were a prominent McKeesport family. Percy Garland was a photographer who invented a lens used by NASA. His wife, Hazel Hill Garland, shown here, was the first black woman in the country to serve as editor in chief for a newspaper, the *Pittsburgh Courier*. She also served as a juror on the panel chosen to select the winners of coveted Pulitzer Prizes. Their daughter, Phyllis, who passed away in 2006, taught journalism for years at Columbia University and retired as dean.

Over the years, McKeesport Hospital has seen many doctors complete their internships and residencies; many stayed to set up practice in McKeesport and its environs. Pictured here (seated) is Dr. Frank Bondi; from left to right (standing) are doctors Mafucci, William Hunt, Berkman, Taksa, Hannah, Kissinger, and Dvorchak.

This is a portrait from about 1930 of the Savage family. Luke Savage Sr. was a city official for many years. Carmelita and Mary were teachers in the McKeesport Area School District. The children, standing from left to right, are Margaret, Luke Jr., Carmelita, Mary, and Elizabeth.

McKeesport's Miss America, Henrietta Leaver, is pictured here with her trophy. The Ringgold Avenue beauty was Miss McKeesport and Miss Pittsburgh before being crowned Miss America in September 1935. Leaver's mother later revealed that her daughter had secretly married John Mustacchio, son of a Locust Street tavern proprietor, in May 1935. This ended her hopes for a stage and modeling career and involvement in the Miss America opportunities.

Pictured here are Mayor George H. Lysle and his wife. Lysle was the great-grandson of John McKee, the founder of McKeesport. Lysle served as mayor from 1913 until 1942, a record-setting 28 years in office. He was instrumental in many improvements in the city, including the redevelopment of Renzie Park, Jerome Boulevard, which was later renamed Lysle Boulevard in his honor, and the Jerome Bridge.

Emilie Renziehausen, for whom Lake Emilie in Renzie Park was named, is shown here during a bond drive during World War II.

The name Henry H. Renziehausen is familiar because his donation of $50,000 to the city led to the development of Renziehausen Park. A member of a family of merchants, he owned a dry goods store on Walnut Street and served on the city council from 1904 to 1913. Children of the day knew Renziehausen as their Santa, because for many years, he held a Christmas party providing treats and toys for hundreds of local children.

Seen here is a photograph from about 1953 of Parade Day. Local politicians pose before the parade with the local radio station WMCK and the Elks lodge in the background. Pictured here, from left to right, are city controller Clifford Flegal, councilman Elwood Rankin, Mayor Charles Kincaid, councilman William Joyce, city treasurer and future mayor Albert Elko, and councilman and future mayor Andrew Jakomas.

This photograph shows the council and the mayor breaking ground for the new city hall in 1960. The architects, Celli-Flynn, are shown at the right checking the blueprints. Pictured, from left to right, are Albert Elko, Richard Helmstadter, D. J. Heatherington, Andrew Jakomas, Harry Helmstadter, and John Lundie.

Here are local politicos checking the poster for the democratic slate elected about 1958. Mayor Andrew "Greeky" Jakomas was first elected in 1954 and was a very colorful character. Pictured from left to right are David Shermer, John Walsh, Albert Elko, Dr. Clifford Bryce, Charles Kearney, and David Rosenberg.

Councilman Julius Lenart, director of parks and recreation, is shown crowning Corrine Kovach, Miss Spirit of 1976 Fife and Drum Corp, Playground Queen of 1968. Runner up was Dawn Pettiford, Miss Altrusa Playground. Standing, from left to right, are Edith Robis, councilman Lenart, and Sylvia Byer.

On October 13, 1962, Pres. John F. Kennedy spoke to a crowd of 25,000 McKeesporters to deliver an 11-minute address in support of the Democrats running in the November election. Kennedy reminded the crowd of his initial visit for his debate with Richard Nixon in 1947.

Shown on the Menzie Dairy buckboard, from left to right, are Milwaukee Braves's Lew Burdett, Menzie Dairy owner Bill Laughlin, and Milwaukee Braves's Warren Spahn. Menzie Dairy was established in 1921 and served the area until November 1, 1976.

111

A McKeesport native, noted Broadway actor, and award-winning playwright, Marc Connelly is shown with Arlene Gallagher of McKeesport Little Theater. Connelly was in McKeesport in the 1960s when the McKeesport Little Theater named its playhouse after him. At that time, the playhouse was located at the corner of Penny and Jenny Lind Streets. Connelly won the Pulitzer Prize for his play *Green Pastures*.

"Coats" or "Old Overcoats" quietly roamed the streets of the city wearing many layers of coats—which is how he received his nickname. He was born Sam Evanoff in 1899 in Czechoslovakia and died at Kane Hospital in 1978. Local artist Jeff Madden was fascinated with "Coats" and placed him in the background of all his paintings. Ken Wilkinson turned this Jeff Madden painting of "Coats" into a stained-glass window, which is now displayed in the McKeesport Heritage Center.

Nine
Just for Fun

Entertainment in the 18th century centered around church and family activities. Folks socialized at quilting bees and cornhusking parties; families attended school and church pageants and celebrated holidays together.

The first theater in town dates back to 1876. In the early 1900s, the city concentrated on the development of parks, and in 1909, the large city pool was built where "1,000 boys" could swim. In the winter, folks had skating parties on the frozen pool. In the early 19th century, the theaters were built along Fifth Avenue. Many watched the movies there, and later, at drive-ins and in playgrounds. Many have even watched movies being filmed in the city.

Always a fanatic sports town, McKeesport was alive with games of all kinds. Summer days have been filled with baseball and softball competition at many levels. Residents have cheered for their school teams as they played basketball, football, and other sports and watched national and local boxers compete in the ring. Residents also love parades. Fifth Avenue has been the site of parades celebrating all manner of events—patriotic, scholastic, and who can forget Santa appearing annually in his sleigh? Even today, in this computer and electronic game era, people still gather together in the parks and theaters and playgrounds "just for fun."

This ornate theater was originally known as White's Opera House. It was the city's oldest playhouse, opening in 1883. Over the years, the theater, located at the corner of Fifth Avenue and Walnut Street, changed names. In 1907, it was the Gayety, and in 1922, it closed as the Orpheum. It was eventually purchased by G. C. Murphy Company, and in 1941, the building was dismantled and replaced by Cox's Department Store.

The John P. Harris Memorial Theater, named for the founder of the Pittsburgh-based Harris Brothers Amusement Company, opened on Fifth Avenue in 1929. With 2,500 seats, the auditorium was designed as an amphitheater enclosed in an immense garden court of a Spanish castle. Called the "Million Dollar Playhouse of the Metropolis of the Mills," the building was converted to a two-screen theater (McKee Cinemas 1 and 2) in the early 1970s and destroyed in "the Famous fire" in 1976.

The lobby of the Capital Theater is pictured here. Although one would not guess from the appearance of this lobby, the theater mainly featured cowboy movies. When the hero caught the villain, cheers erupted in the theater and applause could be heard outside on Fifth Avenue. The featured film would replay throughout the day so some attendees would stay and watch it the second time around.

The city has been the scene of several movies. In 1925, the movie *Steel Mill* was filmed in McKeesport. Hopalong Cassidy (played by William Boyd) is shown in the top row, sixth from the right. Are those some local fellows in the cast?

During the 1950s, the city's department of recreation provided free summer movies in schoolyards throughout the city. This crowd is gathered at the Versailles Avenue School.

This photograph from the 1950s shows Club Belvedere, a social club located on Lincoln Way in White Oak, which was owned by the Sigmund family. It morphed into the White Elephant, a popular hangout for local young people. The building no longer exists.

Tom Thumb weddings served as a source of entertainment in the 1940s. This 1949 wedding, held at Highland Grove School, was sponsored by the McKeesport Recreation Department under the direction of Edith Robis. The bride and groom are Karen Weyman and James Jones.

Children in the 1940s did not wear designer labels. At that time, they frequently wore the hand-me-down clothes of their older brothers and sisters. They spent most of their days playing outdoors, and it did not matter if clothes were clean, old, tattered, torn, or tight fitting, or if coats had their buttons. Shown, from left to right, are Joan Cain, Ellen Vasey, Jim Gaudy, Wilfred Pavlic, and Andrew Vasey.

Some of the old houses in the 1st Ward can be seen with the river in the background. In lieu of municipal playgrounds, these kids make their own fun as the camera catches them playing "dump the garbage can."

A birthday party in the 1930s was a neighborhood event, as shown here when a group of children gathered to celebrate the birthday of Doris Ferry (top left). Not all the younger children seem to be too happy about sitting still to have their photograph taken.

In this December 1959 photograph, Santa is shown beside the holiday mailbox at McKeesport's Baltimore and Ohio Railroad station receiving the letters sent to him from Freddie Kolic, Terri Gray, and Cindy Lou Gray. When Santa was not present for hand deliveries, the postal service promised "to meet all trips to the North Pole."

This photograph shows the McKeesport Soap Box Derby, where kids race down Eden Park Boulevard in their cars hoping to be the first across the finish line and win a chance to go to Akron, Ohio, to compete in the All-American Soap Box Derby. Originally sponsored by the McKeesport Lions Club and Devereaux Chevrolet from 1954 to 1972, it was reopened in 1982 to children from all around the area and is now the Greater Pittsburgh Soap Box Derby.

Viewers hung out windows and lined the sidewalks in the 1920s to view the parade as it went up Evans Avenue. The No. 99 streetcar was probably clanging its bell to move the marchers along. The buildings are a mixture of businesses and apartment buildings. Lange Hall later became a doll factory. The turrets of the hospital can be seen in the upper right. The section of Evans Avenue shown here now houses the hospital's Mansfield Building and a parking garage.

The Henry C. Williams Post of the American Legion is shown here in the Memorial Day parade in 1962. Paying tribute to those who fought in the wars is still carried on in the area, with parades and flags placed on veterans' graves in all the cemeteries. Memorial Day was started in Boalsburg and spread throughout the United States.

Parades have always been, and still are, major events in the city. The rain did not dampen the crowd at the 1940 Memorial Day parade where Boy Scouts are shown marching through the center of the city. Marchers formed straight lines by lining up with streetcar tracks. On the left are the original Royer's and Cox's stores. Murphy's clock is on the right.

Crowds line Fifth Avenue to see the Christmas parade in December 1959. Volunteers pull the Atomic Rocket balloon through the city. The Christmas decorations are strung over the street, and Christmas trees adorn the poles. The Memorial Theater can be seen in the upper-left corner. Union Clothing, Darling Shop, Forsythe Shoe Store, Virginia Dare Clothing, and H. L. Green line the right side of the street. None of the stores are in existence today.

121

Well known to the boxing crowd was promoter Duke O'Hara, shown front and center. Attending the boxing club reunion in 1938 were some of the finest fighters in the area. Among those present was Golden Glove champion George Flaherty, seated to the right of O'Hara.

Baseball and softball have been important pastimes in McKeesport for decades. This fierce-looking group is the Grandview Odds, a pennant-winning team.

In 1987, the Mon Yough Riverfront Entertainment and Cultural Council brought boxing back to town after 20 years with an eight-bout amateur tournament at the Palisades building. The event kicked off a celebration commemorating the 1890s through the 1940s. Leading the committee was Sam LaRosa, who formerly fought at the Duke O'Hara Club back in the late 1920s. Shown here are other former boxers. From left to right are Teddy Movan, Jimmy Loizes, Jack Seger, and Sam LaRosa. Seated is Howard Lindberg.

In 1962, the McKeesport Area Umpires Association honored these original members. From left to right are (first row) Arthur McGrew, Joe Jenkins, Ron Cartwright, and James Smith; (second row) Rege McLaughlin, Eddie Stanko, Rich Stashko, Ed Manning, and John "Bodie" Scott.

123

Bowling was a major sport in the city. Churches, clubs, and businesses formed leagues throughout the city, and competition was fierce. Teams at the National Tube Company were set up by departments. Shown here are the 1935 employee bowling league champions from the Lap Mill and Seamless departments. McKeesporter Norm Henning (not shown) was on the professional bowling circuit.

When the McKeesport youth football team disbanded in the early 1950s, high school coach Duke Weigle asked Bill Lickert to form a new one. The McKeesport Optimist Midgets played for two years before becoming the Little Tigers in 1956. Lickert coached through 1979, leading the team to many victories. Players were taught that discipline and hard work created winners. Many Little Tigers went on to become successful college and professional football players.

The McKeesport High School class of 1955 basketball team coached by Cornelius "Neenie" Campbell brought excitement throughout the season and ended with the Western Pennsylvania Interscholastic Athletic League (WPIAL) championship when they beat Chester at the Palestra in Philadelphia. It was the first championship since 1921. The win brought a citywide day of celebrations. Pictured from left to right, are (first row) ? Rankin, ? Pryor, ? Protz, S. Heller, ? Markovich, ? Gibbons, ? VanEman, ? Robinson; (second row) coach Campbell, ? Danko, ? Falas, ? Kuremsky, ? Shample, ? Ivkovich, ? Ziobro, ? Krajack.

Sam Vidnovic, a longtime broadcaster, politician, and International Village emcee, is interviewing coach Campbell, on radio station WMCK. The station, which began broadcasting in 1947, later changed its call letters to WIXZ. This interview occurred in 1954, a year before coach Campbell's team won the state basketball championship.

From McKeesport High School Tigers to Olympic gold medalists, Swin Cash (left) and Rick Krivda are introduced by Mayor Jim Brewster at the dedication of Olympic Corner in Renzie Park. Cash won a pair of NCAA titles at the University of Connecticut and the WNBA championship with the Detroit Shock. Krivda broke all records as a southpaw pitcher at California University of Pennsylvania. He played major league baseball in Baltimore, Cleveland, and Cincinnati.

Recognizing the recreational value of the city's waterways, McKeesport has developed and expanded the marina on the Youghiogheny River near the point. When the marina suffered ice damage several winters ago, new retractable piers were installed. Boaters from around the area now dock their boats at the McKeesport Marina.

A rainy day along Lincoln Way in White Oak is pictured here. Shown are the Dairy Queen, Genard's, and Rainbow Gardens Drive-in Theatre, all popular spots during the late 1950s. All of the businesses at the intersection of Lincoln Way and Route 48 were demolished in the mid-1960s to make way for a cloverleaf intersection of a widened Route 48. However, the Pennsylvania Department of Transportation ran short of funds and the cloverleaf was never constructed.

Ever since the 1800s, boxing has been a major sport in town. It was not unusual to see professional boxers in the area training for the next big bout. Here fans gather around the ring set up at Rainbow Gardens to watch Arnold Cream, or "Jersey Joe" Wolcott, work out around 1950.

ACROSS AMERICA, PEOPLE ARE DISCOVERING SOMETHING WONDERFUL. THEIR HERITAGE.

Arcadia Publishing is the leading local history publisher in the United States. With more than 3,000 titles in print and hundreds of new titles released every year, Arcadia has extensive specialized experience chronicling the history of communities and celebrating America's hidden stories, bringing to life the people, places, and events from the past. To discover the history of other communities across the nation, please visit:

www.arcadiapublishing.com

Customized search tools allow you to find regional history books about the town where you grew up, the cities where your friends and family live, the town where your parents met, or even that retirement spot you've been dreaming about.